PRACTICAL PRIVACY

How to Keep Your Life...
and Your Personal Data...
Out of the Public Information
Marketplace

SILVER LAKE PUBLISHING
LOS ANGELES, CA ◆ ABERDEEN, WA

Practical Privacy

How to Keep Your Life...and Your Personal Data...Out of the Public Information Marketplace.

First edition, 2007
Copyright © 2007 by Silver Lake Publishing

Silver Lake Publishing
111 East Wishkah Street
Aberdeen, WA 98520
•
P.O. Box 29460
Los Angeles, CA 90029

For a list of other publications or for more information from Silver Lake Publishing, please call 1.360.532.5758. You can find our Web site at www.silverlakepub.com.

The Silver Lake Editors
Practical Privacy
Includes index.
Pages: 270

ISBN: 1-56343-799-6

do that...but most of our laws seem to *encourage* the State use of our personal information.

Instead, we look for other ways to protect ourselves. Sometimes, we have to pay for privacy—in the same way we pay for an unlisted phone number. Sometimes, we change our behavior—do certain things or avoid certain things—to keep our privacy.

Privacy rights are enshrined in the U.S. Constitution for a reason—a democracy requires respect for individual autonomy. And autonomy is only meaningful if individuals are confident that they **aren't always being watched**.

This is important because *privacy* means more than just anonymity (that is, not having a recognizable identity). **Privacy is an affirmative control over one's personal information.** The U.S. federal government has recognized this type of privacy as:

> the claim of individuals, groups or institutions to determine for themselves when, how and to what extent information about them is communicated.

That's a good, working definition of privacy.

Sadly, the government guideline that used it—the HIPAA Privacy Rule—was eventually changed (see Chapter 9 for more details). But we'll still use it in this book.

A HISTORY OF PRIVACY RIGHTS

The U.S. Constitution talks about many rights; but **it doesn't mention anything about a right to privacy**. The concept of a distinct right to privacy first appeared in an 1890 *Harvard Law Review* article by Samuel Warren and Louis Brandeis. They used the term in proposing a new civil damage—**invasion of privacy**. The article considered the legal results of newspapers printing lurid accounts of the personal lives of some prominent Boston families.

Warren and Brandeis distinguished invasion of privacy from injury to reputation; they argued that invasion of privacy was a bigger harm, one that damaged a person's sense of his own independence, integrity and dignity. They claimed that **privacy was a *personal* right**—not a just property right, as traditionally thought.

Brandeis eventually became a Supreme Court Justice. He continued to express opinions that reflected the ideas in his 1890 article. For example, he wrote a famous dissent to the 1928 decision *Olmstead v. U.S.*, which upheld the right of government agents (specifically, Eliot Ness and his "Untouchables") to tap the telephone lines of bootleggers—as long as the tap was made at a point between the suspect's home and office. Brandeis wrote:

> The makers of our Constitution understood the need to secure conditions favorable to the pursuit of happiness, and the protections guaranteed by this are much broader in scope, and include the right to life and

ACKNOWLEDGMENTS

The Silver Lake Editors who have contributed to this book are Sander Alvarez, Esq., Irwin "Tex" Meyerson, Esq., Kristin Loberg and James Walsh.

This is the 18th title in Silver Lake Publishing's series of books dealing with risk and economic issues that face people living in the United States and other developed countries. In this book, we refer to statutes and legal decisions from the United States—but the spirit of the discussion about personal privacy can apply beyond the jurisdictions cited.

This book is intended to make the theories and practices of personal privacy understandable. The Silver Lake Editors welcome feedback. Please call us at 1.360.532.5758 during regular business hours, Pacific time. Fax us at 1.360.532.5728. Or e-mail us at **TheEditors@silverlakepub.com**.

James Walsh, Publisher

TABLE OF CONTENTS

1

WHAT *IS* PRIVACY?

In 1999, Sun Microsystems founder Scott McNealy famously said that in the Internet world **people "have no privacy—get over it**." McNealy's quote has been repeated frequently ever since; often by people who aren't sure whether it's right or wrong.

This book is dedicated to the proposition that McNealy's quote is **colorful...but wrong**. In the wired world, you *can* have privacy. You just have to be smart about how you get it. And keep it.

> This will book will give you tools for doing so. And the first, most important, tool is an understanding of exactly what "privacy" means. That's not as easy as it might seem.

In its 1975 medical privacy decision *Whalen v. Roe*, the U.S. Supreme Court wrote:

> The cases sometimes characterized as protecting "privacy" have in fact involved at least two different kinds of interests. One is

the individual interest in **avoiding disclosure of personal matters**, and another is the interest in **independence in making certain kinds of important decisions**.

> **That bears repeating. Two types of privacy: One is avoiding personal disclosure and the other is independence in making decisions.**

The *Whalen* decision was a sign of things to come. It involved early computer databases that held individuals' medical information—and how certain companies and government agencies were accessing that data. Justice William Brennan's concurrence to the main conclusion described issues that remain important, more than 30 years later:

> ...collection and storage of data by the State that is in itself legitimate is not rendered unconstitutional simply because new technology makes the State's operations more efficient. However, the Constitution puts limits not only on the type of information the State may gather, but also on the means it may use to gather it. **The central storage and easy accessibility of computerized data vastly increase the potential for abuse of that information**, and...future developments [may] demonstrate the necessity of some curb on such technology.

So, here we are—looking for ways to curb "such technology" so that we can maintain some privacy. Justice Brennan probably guessed we'd use laws to

an inviolate personality—the **right to be left alone**—the most comprehensive of rights and the right most valued by civilized men. ...as time works, subtler and **more far-reaching means of invading privacy will become available** to the government.

Brandeis anticipated the technological advances that we have seen in the Information Age of the 1990s and 2000s. And he knew that governments throughout history have tried to restrict privacy.

While federal law describes privacy rights only indirectly, various state laws are more explicit.

The original "Privacy Act," New York Civil Rights Law 50 and 51, was enacted in 1903 in response to the precedent decision *Robertson v. Rochester Folding Box Co.*, which involved a little girl—who was not a celebrity—who sued a flour company for using her picture to promote its product. The New York Court of Appeals had held that the little girl had **no common law "right to privacy,"** but observed that the legislature could create such a right.

So, it did. And many other states followed.

> **The New York Privacy Act not only prohibits the use of a person's name to promote a product or service, but also prohibits any other exploitation of a person's name, image or likeness for the "purpose of trade."**

Privacy laws prohibit photographers from selling photographs of a person without first obtaining that person's consent. The main exception to this rule applies to **photographs appearing in news media** protected by the First Amendment.

This distinction came to a point in the 1988 federal court decision *Mendonsa v. Time, Inc.* The case involved Time's commercial exploitation of **a famous photograph of a sailor kissing a nurse in Times Square** at the end of World War II.

Mendonsa contended that he was the "kissing sailor" and that Time had violated his rights under Rhode Island's privacy act by making commercial use of his photograph. A federal court in Rhode Island held that the initial publication of the photograph in *Life* magazine did not violate the privacy act because it illustrated a newsworthy event.

However, Time's subsequent offer to sell reprints of the photograph to the public at $1,600 each violated the "purpose of trade" branch of the Rhode Island law by exploiting Mendonsa's likeness for commercial purposes.

PRIVACY AS A "PENUMBRA"

The U.S. Supreme Court recognized a federal right to privacy for the first time in the 1965 decision *Griswold v. Connecticut*. In that case, the Court ruled that Connecticut's birth-control law (making it a crime to give out information or instructions on the use of birth control devices) violated privacy rights of married people and others. In the decision, Justice William O. Douglas famously wrote:

Previous cases suggest that the specific guarantees in the Bill of Rights have **penumbras, formed by emanations from those guarantees that give them substance**. Various guarantees create zones of privacy, such as the First Amendment right of association, the Third Amendment prohibition against quartering soldiers in a home, the Fourth Amendment right to be secure in one's person, house, papers, and effects Governments throughout history have tried to restrict privacy.... These cases press for recognition of the **penumbral rights of privacy and repose**.

"REASONABLE EXPECTATION"

Another important Supreme Court decision on the right of privacy is 1967's *Katz v. United States*. It is a complex case; but it did a lot to build on *Griswold*. Here are some of the things that make the *Katz* decision significant:

- It shifted the definition of privacy from a focus on **property** to a focus on **people** (previous conceptions were derived mainly from the "property" concept in life, liberty, and property; and from the common law trespass doctrine that "every man's home is his castle").

- It balanced the interest in protecting individuals from government intrusion with the interest in protecting society from criminals (creating a two-prong

test for "reasonable expectation" based on this balance).

The "**reasonable expectation**" test is a two-prong test based on:

(1) **subjective privacy**—whether a person exhibited a personal expectation to be left alone from government intrusion;

(2) **objective privacy**—whether the personal expectation is one that society is prepared to recognize as reasonable or one that's beyond what society is willing to recognize.

Basing objective privacy on societal standards can create some tricky problems. (For example: Immediately after the 9/11 attacks, some politicians argued that society was willing to recognize **more exceptions to privacy expectations** than it would at other times.)

These problems led the Court to some interesting conclusions in the abortion precedent *Roe v. Wade*, six years later. In terms of legal theory, *Roe v. Wade* shifted the definition of privacy **from an** *associational* conception to a *person-based* conception.

Associational conceptions of privacy focused on the idea of sacrosanct "privileges"—husband-wife, doctor-patient, lawyer-client, etc. Person-based conceptions focused on an individual's independence and self-ownership.

SEARCH & SEIZURE ISSUES

What is "beyond" society's conception of a reasonable expectation of privacy? Mostly, situations that would be **"exceptions" to normal search warrants**. In other words, searches:

- of items **open to plain view**, hearing, smell and touch;

- in open fields;

- in public places;

- of abandoned property.

Most U.S. law defines a "search" as **any invasion of privacy by a government official** where there had been a reasonable expectation of privacy. A "seizure" is any **deprivation of liberty or property**. The Constitution strictly limits government searches and seizures; that's why courts have ruled that the "exceptions" come with various conditions.

A search of objects in **plain view**, hearing, smell and touch requires that three conditions be met:

1) officers are lawfully present;

2) detection occurs without advanced technology (flashlight and binoculars are okay, though);

3) detection is inadvertent or immediately apparent.

A search of objects in **open fields** requires calculation of the curtilage, based on:

- distance from a house or nearby structure;

- presence or absence of a fence;

- use or purpose of area;

- measures taken to prevent public view

A search of objects in **public places** often requires calculation of whether:

- the area is actually open to public;

- the area is enclosed or partitioned;

- the area can be seen over and under partitions or through cracks or gaps.

And a search of **abandoned property** requires proving the elements of:

- the owner's intent to throw away property; and

- acts that imply that intent.

PRIVACY VERSUS SECURITY

Many people think of privacy and security as opposites—that a society has to give up one to have the other. But this isn't really true. As we'll see in more detail later in this book, privacy can act as a valuable control on the "false positives" that security efforts, left unchecked, often suffer.

Creating a security system that can identify and locate terrorists is difficult because of something mathematicians call a *base rate fallacy*. There are so few

terrorists out there that even a highly accurate test will generate lots of false positives—false alarms. The challenge is to **minimize the false alarms**.

Terrorist attacks are extremely rare. No matter how good a security guard is, if he tries to identify a suspect in an airport he's going to be wrong most of the time. So, he needs a system that both identifies suspect traits—but also honors controls on how a suspect can be treated.

Strictly-enforced privacy rules can keep security systems from overreacting to false positives.

PRIVACY VERSUS CONVENIENCE

A bigger challenge to privacy rights—bigger than security conflicts—is **convenience**. Most people want the details of their daily lives to be easy; and they're often willing to give up privacy for that ease.

Americans, especially, seem to want convenience and privacy. In that order. And to many Americans, "convenience" means anonymity—especially in retail transactions and on-line activities. But, in these cases, anonymity and privacy are not the same thing. In fact, anonymity can conflict with privacy.

The problem here: Some of what passes as "convenience" in the retail or on-line worlds is really **convenience for the system** (including corporate suppliers) marketed to look like convenience for the consumer.

So, privacy used to mean curtains in your windows and a quiet voice in public places. Now it means a hundred decisions every day; and **making some choices that are inconvenient**—like declining grocery-store discount cards, avoiding certain Internet chat rooms or paying cash at restaurants.

Modern notions of privacy are shaped by technology...and by the degree to which we have assimilated technology into our daily lives. *Anonymity* **may no longer be possible** in a MySpace world; but privacy—clearly defined and carefully maintained—is still possible.

This will mean changing the way you do things; it may mean seeming old-fashioned. You may need to resist the trend of doing business in an automated manner with people you don't know.

You may need to take the time to get to know the people you're doing business with...or chatting with on-line. It may seem counter-intuitive, but this can help you maintain your privacy.

Choosing convenience in the consumer or on-line worlds leaves many people with a nagging sense of fear about their privacy. According to an October 2006 survey conducted by the Internet news site MSNBC.com: While most people felt uneasy about their privacy, **they had trouble defining** *privacy*. As a result, they were willing to tolerate actions by government and corporations that experts considered unwise.

Despite their stated skepticism, respondents expressed a willingness to share detailed personal information with authority figures:

- About 40 percent said they would willingly submit to voluntary fingerprinting at their local police station.

- 60 percent said they would carry a high-tech driver's license with an embedded ID chip or biometric device.

- Nearly 20 percent said they would agree to have a microchip implanted under their skin to identify them and access their medical histories.

Many respondents expressed discomfort with collection and sharing of data by private-sector companies. And not all data-gathering behaviors were deemed acceptable, even for the government:

- 92 percent said they did not want the government tracking their Web surfing habits or reading their e-mail, electronically tracking their automobiles or eavesdropping on telephone calls.

- 62 percent said they were concerned or very concerned about the government obtaining a list of telephone numbers they had dialed.

- 67 percent said they weren't willing to surrender more information or submit to intense questioning at airports.

But this last point was confusing. A majority of the survey respondents also said they supported the in-

creased use of biometric security systems in airports. **Most privacy advocates consider biometric security systems a major threat to privacy.**

In order to control how your personal information is collected and used (the definition of "privacy" that we find most useful), you may have to change the way you think about **privacy, anonymity, trust and identity**.

In this book, we'll help you do so.

2

CAMERAS, GPS, RFIDS
& PHYSICAL PRIVACY

Accepting surveillance cameras on street corners as a deterrent against crime or terrorist attacks might seem like a reasonable response to real risks. But **the consequences of living in a "surveillance society" go beyond cameras**.

One clear example: In early May 2007, the local media in New York City buzzed with a story that touched notions of privacy from various angles.

Chase Bank—one of the largest and highest-profile financial institutions in America's biggest city—had been in a dispute for several months with the Service Employees International Union (SEIU) about the bank's use of nonunion security personnel in its branches and offices. The SEIU decided to try to embarrass the bank into switching to unionized security. It sent **"researchers" (really, more like private investigators)** armed with video cameras to root around Chase Bank's garbage.

The researchers were successful right away. They found bank account statements, credit reports and other personal documents easily visible in trash bags

and containers around Chase branches and offices. They recorded what they found and posted the videos on the popular Internet video exchange YouTube.com.

The videos emphasized that Chase's garbage was an identity thief's dream. "Social Security numbers here as well as date of birth," one person could be heard saying on one video, pointing to the documents.

> Such detailed information was supposed to be protected by the Bank—specifically, according to Chase privacy policies, documents containing personal information were supposed to be shredded before being thrown away.

When snippets of the videos had been played on local television news and other media outlets, Chase realized it had a publicity problem.

Media experts lined up to comment on the issue. Many noted that the popularity of video exchanges like YouTube.com was **changing the notion of "private" and "public" information**. They pointed out that former U.S. Senator George Allen of Virginia had made a fool of himself—and recently lost his Senate seat—by using an allegedly racist term for a dark-skinned person that was recorded and posted on the Internet. They also pointed to the comedian Michael Richards' use of much stronger racist words during a performance that was recorded and posted on the Internet.

What did Chase Bank, a second-rate politician and a third-rate comedian have in common? They had **all assumed that their words or actions were "private"** and not likely to become national news. They were all wrong. Video technology has become inexpensive and commonplace (the comedian's racist rant had been recorded on a cell phone/camera).

> Cheap and plentiful video cameras have undermined the assumption that what you say in behind a closed door or in front on a few people is private in any meaningful sense.

Approximately one in three American cell phone owners have camera-phones in 2007. **Tens of millions of pocket-size cameras**—capable of taking still pictures and short movies—are changing everything. Political speeches, law enforcement activities, work-related meetings...even things like children's practices and sports events...are all more public than they've ever been.

These changes are consistent with the larger societal trend away from anonymity and toward a notion of **privacy that requires careful maintenance**. They are also making people cautious of their behavior outside of clearly "private" places. Even your garbage may end up on YouTube.com.

The science-fiction writer Robert Heinlein once wrote, "An armed society is a polite society." His observation still works when the **society is "armed" with cameras**.

GPS TRACKING...PEOPLE

And the technology advances aren't just cameras. In January 2007, the Commonwealth of Massachusetts authorized judges to require domestic abusers who violate existing restraining orders to **wear global position system (GPS) tracking devices**.

The device would automatically notify authorities —and potential victims—if an offender entered a geographic "exclusion zone" set by a court. Lt. Governor Kerry Healey, a sponsor of the plan, said:

> This law leverages the power of technology to provide a much-needed level of protection to victims of domestic abuse, too many of whom continue to be victimized even after obtaining a restraining order against their abusers. ...This new ability to exclude offenders from areas frequented by the victims will not only protect them from further abuse, it will give them their lives back.

Massachusetts isn't alone. Other states—including Colorado, Florida, Utah and Washington—have laws that allow GPS monitoring of batterers. Also, several federal court systems use GPS systems to keep track of parolees or defendants awaiting trial.

> **First developed by the Department of Defense in the late 1970s, the GPS relies on a network of satellites transmitting signals to receivers to determine a receiver's location, speed and direction.**

As GPS receivers have shrunk to the size of a cell phone, the technology is available to nearly everyone—from hikers navigating wilderness paths to drivers navigating city traffic.

...to criminals out on parole. Common GPS tracking units can take the form of a **familiar one-piece "ankle bracelet"** or a two-piece device that looks like a wristwatch and a cell phone. If the unit is left behind or tampered with, an alert can be sent directly to a supervising officer. Some GPS units let officers send text or voice messages to the receiver worn by the offender.

Lisa Nowak, a former NASA astronaut facing charges of trying to kidnap a romantic rival, was ordered to wear a GPS tracking device as a condition of her bail while waiting for trial in a Texas court. Employees at SecureAlert, the Utah-based company that monitored Nowak's GPS tracking device, could watch her movements on a series of computer maps, zooming in or out as needed.

According to John Hughes, Assistant Director of the Office of Probation and Pretrial Services for the U.S. Courts system: "GPS monitoring is becoming an increasingly favored form of electronic monitoring nationwide."

According to law enforcement officials, the **real-time feedback** makes GPS monitoring superior to any other type of electronic monitoring.

The cost of traditional electronic monitoring (which can only establish when a subject leaves his or her residence) is about $4 per day; GPS monitoring can

run $10 per day. So, cost is a factor. But incarceration can cost over $60 per day.

> Corrections professionals look at GPS tracking systems as a way to release more prisoners from overcrowded jails while still restricting their movement.

GPS tracking seems certain to be a growing part of the corrections equation. But, as corrections and law enforcement agents get used to using GPS tracking, they may start applying the technology to **other receivers—like standard cell phones**.

The question is: Will government's enthusiasm for tracking criminals translate into a desire to track free citizens?

RADIO FREQUENCY ID TAGS

Ordering defendants waiting trial or felons free on parole to wear GPS tracking devices may not raise many privacy concerns. By law and tradition, convicted felons can expect less privacy than ordinary citizens. But the institutional approach to "tagging" people may be **a slippery slope away from privacy** for public policy in general.

Radio frequency identification tags (RFIDs) are the next stage on that slope.

RFID technology is different than GPS—but the practical result is much the same. The tags, which range in size from a dime to a pencil point, send

out radio signals that can be tracked by a central monitoring system. The monitoring system can locate the tags precisely...anywhere in the world.

Libraries, schools, government agencies and private sector businesses have used to RFIDs to keep tabs on everything from books to specific pallets of inventory in a warehouse.

RFIDs can also be used to keep tabs on people. A monitoring agency can insert the tags into a person's clothes or other possessions; it can also insert them directly *into* a person. Smaller RFID chips can be inserted under a person's skin.

This last scenario has raised alarms among privacy advocates and civil libertarians. In fact, two states— Wisconsin and North Dakota—have passed laws banning any form of forced implantation of RFIDs in people.

North Dakota's legislation, signed into law in April 2007, forbids anyone from compelling someone else to have an RFID chip injected into his or her skin. When he signed the law South Dakota Governor Mike Hoeven said:

> We need to strike a balance as we continue to develop this technology between what it can do and our civil liberties, our right to privacy.

He emphasized that the law didn't prohibit voluntary "chipping." Military personnel who want an

RFID chip injected so they can be tracked would still be allowed to get a chip. And Hoeven said the law would allow for potential RFID use in corrections or animal control applications.

Some experts pointed out the South Dakota law only addressed situations where a chip was injected; RFIDs can also be swallowed or otherwise connected to human bodies. And it didn't clearly define a "forced implant"—so, a group could make chipping a requirement for a financial reward.

> This last point is the one that has most privacy advocates worried. Legal theorists and economists have predicted that corporate entities will use RFIDs to gather marketing information about how their products are used....and by whom.

Marlin Schneider, the state legislator who sponsored the Wisconsin anti-RFID law, said he was concerned about private-sector retailers and manufacturers that might "implant these things [and] monitor everything we buy, everywhere we go and—perhaps as these technologies develop—everything we say."

KEEPING TABS ON KEEPING TABS

So, advancing technology creates things like cell phone cameras, YouTube.com, GPS tracking systems and RFIDs. Most people focus on the most immediate, personal applications of these developments—the "fun" uses.

But there's a less-direct effect of this technology march. It contributes to **a gradual shrinking of "private" activity**; even though people and companies may not realize what's happening right away.

What's the long-term effect?

The current state of the United Kingdom may provide some clues. The U.K. has long had a more limited concept of privacy than the United States. Britons accept laws (like the country's prohibitions against "antisocial behavior") and technology applications (like police cameras on most urban street corners) that Americans would find objectionable.

The British system has resulted in violent crime rates that are lower than in most developed countries. But there have also been some bad side-effects. In the Spring of 2007, British Information Commissioner Richard Thomas released a report highlighting what he called a "**creeping encroachment**" on civil liberties by various government agencies. Thomas went on to describe the U.K.'s surveillance systems as "**slow social suicide**."

The report accused government ministers of creating a climate of fear through increasing use of closed-circuit television (CCTV) cameras, computerized tracking of shopping habits and plans for ID cards.

The U.K. uses 20 percent of the world's CCTV cameras, with some 4.2 million watching its people. That's **one camera for every 14 citizens**.

Applauding the Thomas report's conclusions, Gareth Crossman of the civil rights group Liberty said:

> Our details are held and shared not because we are under suspicion now but because we *might be* one day. At this rate, future generations will neither enjoy nor understand the concept of privacy.

These worries may be warranted. In late 2006, one local U.K. police force was considering using **unmanned military surveillance drones** to fly over troubled public housing projects. According to Merseyside Police Superintendent John Myles:

> It's a cheap way of doing intelligence and evidence gathering. Put over an antisocial behavior hotspot. It is a significant percentage cheaper than the force helicopter.

So, budgetary concerns trump privacy.

In some cities in Europe and the U.S., a person can be **filmed hundreds of times a day** by surveillance cameras. The best news for privacy is that, most of the time, no one is actually watching. But the development of so-called "**intelligent video**"—software that raises an alarm if something on camera appears amiss—means Big Brother will soon be able to keep a more effective watch.

Combining **motion detection** technology with things like the multiple-player capabilities of video

game software, these new systems can detect people loitering, walking in circles or leaving packages.

Some programs made video available to hundreds or thousands of volunteers who constitute a "**distributed system**" for monitoring camera shots.

Some recent examples:

- The port of Jacksonville, Florida dispensed with human monitoring of cameras by sending alerts and live video to the personal digital assistant of the nearest officer on patrol.

- Texas has run a pilot program in which it allowed Internet access to video of unmanned sections of its border with Mexico—and urged citizen viewers to send e-mail if they spotted anything.

FACIAL-RECOGNITION PROGRAMS

If hiring enough people to monitor all of the pictures and data that cameras capture remains a problem, technology firms will provide solutions. One of the most controversial of these solutions is **facial-recognition software**. These programs:

- take existing pictures of the faces of targeted individuals (criminal suspects, alleged terrorists, etc.),

- create mathematical "templates" based on the dimensions and characteristics of those faces and then

- "look" for matches in video and still
 images of people and/or crowds.

In the mid-2000s, the Department of Homeland Security considered a plan that used **facial-recognition software to check photographs of people taken secretly** in airports, train stations and other transit facilities. When news of this plan became public, the strong negative reaction forced DHS to cancel and disavow the whole system.

Still, DHS executives admit the government is funding development of facial-recognition systems.

> At least 19 states have adopted technology to compare driver's license applicants with a photo database—to determine whether an applicant already has a license or is using a false identity.

These programs aim to make the technology work in **one area where it has failed miserably: surveillance.** Police in the cities of Tampa and Virginia Beach removed facial-recognition systems that did not yield a single arrest. During a test at Boston's Logan Airport in 2002, the system **failed 39 percent of the time** to identify volunteers posing as terrorists at security checkpoints.

Among the problems: Facial-recognition systems photograph people at oblique angles or in weak light, both of which create poor images. And determined terrorists can defeat the systems with disguises or clothes that shield their faces.

CHAPTER **3**

PRIVACY ON THE
INTERNET

The Internet's great power is access to information and ease of communicating it. If we define *privacy* as proper limits on distribution of personal information, the potential abounds for conflict between the Internet and privacy.

In January 2007, the Internet search engine Google created some controversy when it resisted a request by the U.S. Department of Justice that it hand over data about what people used its search engine to find on-line. The Feds implied that, if Google didn't cooperate voluntarily, they could get court orders forcing the matter.

The Feds had asked Google for two things:

1) a list of **terms entered into its search engine over a one-week period**, and

2) a million **randomly-selected Web site addresses** from various Google databases.

They wanted this information to support the government's position in a lawsuit (not directly in-

volving Google) over the 1998 **Children's On-line Privacy Protection Act**, which had been blocked by the U.S. Supreme Court because of legal challenges over how it was being enforced.

Google—like most Internet search engines—retains log files that record search terms used, Web sites visited and the Internet Protocol address and browser type of the computer for every search conducted through its site.

The Feds insisted that the order wouldn't violate industry-standard **privacy policies**; they noted that some of Google's competitors had already complied.

Indeed, rival search engine Yahoo publicly announced that **it had complied** with a similar government subpoena "on a limited basis and did not provide any personally identifiable information."

And, according to Ken Moss, the general manager for MSN/Web Search at Microsoft:

> Over the summer we were subpoenaed by the DOJ regarding a lawsuit. The subpoena requested that we produce data from our search service. ...The applicable parties to the case received this data, and the parties agreed that the information specific to this case would remain confidential. Specifically, we produced a random sample of pages from our index and some aggregated query logs that listed queries and how often they

occurred. Absolutely no personal data was involved.

But Google said a broad sample of search terms could **reveal the identities of its users**. And Google executives were concerned about the "chilling effect" that cooperation might have. Providing the data might make its users think Google was generally willing to reveal personal information—and, therefore, they might hesitate to use Google for future searches.

Google's resistance prompted U.S. Attorney General Alberto Gonzales to ask a federal judge in California for an order forcing the search company to hand over the records. The search engine's lawyers vowed they'd fight the order.

At the same time, Google was looking for ways to gather **more information about its users** and the searches they were making through its service…for its own purposes.

While his legal staff was still sparring with the Justice Department, Google CEO Eric Schmidt told industry media outlets that gathering **more personal data** was a key way for the company to expand—and the logical extension of its mission to organize the world's information. He told a group of tech journalists at a London press conference:

> We are very early in the **total information** we have within Google. The algorithms

will get better and we will get better at personalization. The goal is to enable Google users to be able to ask the question such as "What shall I do tomorrow?" and "What job shall I take?" ...That is the most important aspect of Google's expansion.

Schmidt pointed to services like iGoogle (a series of templates for customizing the standard Google search page and publishing personal content) and "personalized search" (a system for storing an individual's Web-surfing history in order to refine future searches) were central to his plans.

Whether users would *want* his company to know so much about them was a point that Schmidt hadn't seemed to consider.

There are legitimate, technical reasons that Internet search engines keep track of which computers make what searches. Such **data retention** allows them to prevent users from rigging search results.

But, as the Internet becomes **the world's biggest media channel**, the personal information search engines keep becomes a tempting target for legitimate advertisers and not-so-legitimate scammers.

A person's Internet search history says a lot about his politics, sex life, religious beliefs, finances, health and much more. This is more intimate information than most people realize—and private, for-profit companies like Google and Yahoo control it.

The important thing to remember about Internet search engines is that **they make their money from selling advertising**. And, the more focused the advertising can be, the more advertisers are willing to pay. In order to sell that focused advertising, companies like Google and Yahoo have to convince users to offer up personal preferences and interests. Their standard offer to attract these details is convenience—faster and more specific search results, easier-to-use "personalized" information.

That process requires a considerable **surrender of privacy** on the part of the user...namely, *you*.

A slightly faster search response or steady news on a TV star may not be worth giving Google the explicit right to **record and use your history of Web searches**. Google may *already be* recording your searches; it has run into regulatory problems with the European Union over such data retention. But, if you use its personalized services, you give Google **more opportunity to keep tabs on you**.

All major search engines have **privacy policies**. But not all of these policies make clear sense. For example, Google's "Privacy Policy Highlights" state:

> Google collects personal information when you register for a Google service or otherwise voluntarily provide such information. We may **combine personal information collected from you with information from other Google services or third parties** to provide a better user experience, including customizing content for you.

...Google's servers automatically record information when you visit our website or use some of our products, including the URL, IP address, browser type and language, and the date and time of your request.

...We may use personal information to provide the services you've requested, including services that **display customized content and advertising**.

...We may share aggregated non-personal information with third parties outside of Google. ...We may also share information with third parties in limited circumstances, including when complying with legal process, preventing fraud or imminent harm, and ensuring the security of our network and services.

The phrase "we may" certainly occurs a lot in those highlights. And **it's not immediately clear** what combining "personal information collected from you" with information from third parties "to provide a better user experience" means.

Google isn't alone in this. Yahoo's privacy policy says that it "may combine information about you that we have with information we obtain from business partners or other companies" and that it may use the data to contact users.

Another privacy concern: **Google uses cookies—** small bits of programming code that are stored in a user's computer and link a specific user with his or

her past activities. If a cookie is used and is not deleted by the user, future searches may then be linked to that cookie. Many Internet Web sites use cookies; but Google's last longer. They're set to function **until the year 2038**.

Of course, users can delete or disable the cookies; but few realize that the things are in their machines. And every time you use Google, Yahoo or other major search engines, **they install new cookies**.

How to get around this invasion? With a little bit of effort, you can access the Internet through anonymizing proxy networks (the best-known of these may be the Electronic Frontier Foundation's Tor system— details available at **tor.eff.org**). These networks bounce Internet communication through a series of routers that encrypt and decrypt it so that its origination can't be traced.

This may seem like a lot of inconvenience to keep ad-selling search engines out of your business. But it's important. Proof? Hot-shot executives at the major search engines don't like other people peering into *their* personal preferences.

In July 2005, the Internet news service Cnet.com ran an article that used Google's search engine to **investigate its CEO Schmidt**. The Cnet.com reporter found detailed—if rather predictable—information about Schmidt's finances, political contributions and personal activities. But Schmidt objected to this publication of his personal informa-

tion and **banned company employees from speaking with Cnet.com** reporters for a year. His response struck some as hypocritical.

REGULATING DATA RETENTION

Data retention has been an issue with Internet search engines as long as there has been an Internet to search. Generally, **the longer a company retains its search data, the less it values user privacy**.

In other words, the "best" retention in terms of user privacy would be none.

In early 2007, the Bush administration signaled its intent to draft new rules **requiring Internet service providers to retain user information for up to two years**. Attorney General Alberto Gonzales denied that the plan was a government power grab; he emphasized that it did not involve "data retained by government, but data retained by ISPs that could be accessed with a court order." He also argued that "reasonable" data retention was necessary to help investigators of on-line sex crimes, etc.

> **Privacy advocates oppose mandatory data retention rules because they allow police to obtain records of e-mail chatter, Web browsing history or chatroom activity that normally would have been discarded after a few months—or never kept at all.**

Of course, there already *was* a federal law regulating data retention. The 1996 **Electronic Commu-**

nication **Transactional Records Act** (ECTRA) requires ISPs to retain user data for up to 90 days if notified by government agencies.

But Gonzales said the **lack of consistent data retention** by ISPs was a "roadblock" to investigations. He described, for example, a situation in which an investigator may be able to request an IP address for a suspected phisher from Microsoft's Hotmail service. By the time the investigator took that IP address back to the ISP for more information about the suspect, 90 days might have passed and the information might have been purged.

"FULL PIPE" SURVEILLANCE

While Gonzales was justifying his administration's desire for access to more search data, Internet privacy advocates had already moved on asking questions about the FBI's searches of private records. Specifically, the FBI appeared to have adopted **invasive Internet surveillance techniques** that collected data on many innocent Americans.

Instead of recording only what a particular suspect was doing, FBI agents were recording the activities of thousands of Internet users at a time into massive databases. Those databases could then be searched for names, e-mail addresses or keywords.

Such techniques were broader and potentially more invasive of privacy than the FBI's ill-fated **Carni-**

vore surveillance system—which had been abandoned in the early 2000s.

The FBI tactics were similar to those employed when police obtain a court order and an Internet service provider can't "isolate the particular person or IP address." But the FBI was doing so *without* court orders. All it needed was a few cooperative ISPs.

That kind of **full-pipe surveillance** could record *all* Internet traffic, including Web browsing and e-mail messages. Interception typically took place inside an ISP's network—at the junction point of a router or network switch. Some Internet experts said that by 2006 full-pipe recording had become the Feds' **default method for Internet surveillance**.

According to Kevin Bankston, an attorney at the Electronic Frontier Foundation, the FBI was "intercepting everyone and then choosing their targets."

> These actions had been predicted. When the FBI announced in 2004 it was abandoning the Carnivore program, spokespeople said the Bureau would rely on ISPs to conduct future surveillance.

Another possible legal problem for the FBI was that its actions seemed to violate the terms of the 1994 **Communications Assistance for Law Enforcement Act** (CALEA), which required investigators to "minimize the interception of communications not otherwise subject to interception" and keep a supervising judge informed of what they do.

Drafted after the 1993 attack on the World Trade Center in New York, CALEA was intended to make it easier for FBI agents and other federal investigators to set wiretaps and gather cell phone records. It had always **troubled privacy advocates**. The minimization requirements were designed to maintain at least a modicum of privacy by limiting police eavesdropping on innocuous conversations.

The most frequently cited sections of CALEA only mention **real-time interception**—they don't authorize the creation of databases with information on thousands of innocent targets. But FBI read the law creatively, citing a less-known section that stated:

> In the event the intercepted communication is in a code or foreign language, and an expert in that foreign language or code is not reasonably available during the interception period, minimization may be accomplished as soon as practicable after such interception.

The FBI's defense of its tactics was that, because digital communications amounted to a foreign language or code, federal agents were legally permitted to record everything and sort through it later.

These policies weren't new, either. For years, the Feds had been promoting the idea of **requiring Internet service providers to retain records** of their customers' on-line activities. Justice Department officials suggested the idea at a private meet-

ing with ISPs and the National Center for Missing and Exploited Children in April 2005.

CHILD PORN AS THE EXCUSE

The suggestion seemed to originate with the Justice Department's Child Exploitation and Obscenity Section, which enforced federal child pornography laws. So, again, **child porn was the excuse**.

But, once mandated by law, **the logs could be mined for other information**.

Child pornography is a problem that seems to be worsened by the **apparent anonymity of the Internet**. But it's also become an excuse that politicians use to draft cynical laws that invade the privacy of people who never look at dirty pictures.

In February 2007, a bill in the U.S. Senate lay the groundwork for a **national database of illegal images** that ISPs would use to flag and report suspicious content to police. The proposal, introduced by Sen. John McCain, also required ISPs and certain Web sites to **alert the government** about illegal images of minors. Failure to do would be punished by criminal penalties including steep fines.

The bill (called the Securing Adolescents from Exploitation-On-line Act...that's "SAFE-On-line Act" for anyone bad at acronyms) put **a heavy enforcement burden on ISPs** and sites that provide instant messaging or e-mail services.

The list of offenses that had to be reported included child exploitation, selling a minor for sexual pur-

poses and using "misleading" domain names to trick someone into viewing illegal material. It also covered obscene images of minors including ones in a "drawing, cartoon, sculpture, or painting." (The bill warned that **it was not necessary "that the minor depicted actually exist."**)

The important point here for people surfing the Internet: Your actions—including looking at pornography, if you choose to do that—may seem like a private matter. But they're not. Your ISP tracks the sites you visit with a number is assigns to your computer. And the government can press that ISP to hand over its records.

This is more than just an issue of setting your browser so that it doesn't store the sites you visit or of buying so-called "clean screen" programs that erase any evidence of your Internet use. **Those solutions just work on *your* computer.** They might be enough to satisfy an employer or a spouse; but they won't do anything about CALEA.

The FBI investigations use information stored on the ISP's hardware. The only way you can obscure that is by using anonymizing software (again, like the Tor system we mentioned earlier)...but even those systems may not be enough.

DMCA...BAD LAW, BAD RESULTS

Another big threat to personal privacy on the Internet comes from an unexpected source.

The **Digital Millennium Copyright Act** (DMCA) is a law passed by Congress in the late 1990s. It's designed to extend standard copyright protections into the Internet era. But, like many laws that try to "extend" or expand existing laws, it has had unforeseen consequences. Specifically, it shaves away at on-line privacy.

One of the DMCA's main enforcement tools is a so-called "**512(h) subpoena**" (named after the section of the DMCA that creates it).

According to the law, someone whose intellectual property has been used without permission on-line can serve a 512(h) subpoena to the relevant ISP or other access provider to find out the identity of the person or group that's violating the copyright. In some situations, government agencies working on behalf of someone whose copyright has been violated can also use the subpoenas.

> But the DMCA relies on copyright owners to use 512(h) subpoenas. The law is designed to use private legal actions as a central enforcement mechanism. Again, the Feds put the burden of enforcement on private parties—who operate under fewer restrictions.

According to congressional testimony of Alan Davidson, Associate Director of the Washington, D.C.-based Center for Democracy & Technology:

> ...serious privacy issues are raised by the unique subpoena power currently granted

any copyright holder under 512(h), which too easily allows the identity of Internet users to be unmasked wrongly or by mistake, without the user's knowledge, without the possibility of redress, and without oversight. ... The 512(h) process allows the disclosure of private information with few protections against abuse or misuse.

Davidson went on to point out that many peer-to-peer users inadvertently share personal information on their computers and that **spyware within some peer-to-peer networks** creates privacy issues.

User privacy is a cornerstone of Internet commerce. People expect that their activities on-line can be anonymous (or at least private) when they visit health sites, make political statements or visit chat rooms. Revealing the identity of a person on-line can mean publicizing that person's health status, political beliefs, sexual interests or religion.

> **For these reasons, standard industry practices and most Internet-related law protect user identity; ISPs and other access providers normally have restrictions on when and how they can share user information with government agencies. DMCA 512(h) subpoenas are designed to pierce those protections.**

Mainstream record companies or movie studios aren't the only entities that use the subpoenas. In 2002 and 2003, California-based Titan Media stirred up some controversy when it tried to use 512(h) sub-

poenas to track down Internet users who were illegally **reproducing clips of its films on-line**.

Titan makes gay pornography. Its attempts to use the 512(h) subpoenas raised the prospect that **it would be "outing" people** who didn't want their interest in gay sex movies made public.

Eventually, because of privacy objections from its *legitimate* customers, Titan backed away from using the subpoenas. It focused instead on using technology to make accessing its films difficult for unauthorized (that is, non-paying or underage) users.

But the lesson for the individual user bears repeating: If you go on-line to look at pornography, talk extreme politics or do anything else that you wouldn't want made public—**stop and rethink what you're doing**. Your Internet service provider assigns a unique number to your computer and, in most situations, logs all the Web sites that it visits. **These logs can be made public under the DMCA.**

Among the other privacy concerns raised by the 512(h) subpoenas are:

- **No notice to end-users.** The disclosure of personally identifying information takes place without the requirement of any notice to the end user that his or her identity has been unmasked. People typically have no idea that their personal information is being revealed.

- **No judicial oversight.** No judge ever looks at a 512(h) application, no weighing of facts is ever made beyond the

assertions in the application, and no user can challenge those assertions.

- **No confidentiality requirement or limitations on future use of data.** There is little effective limitation on how the information disclosed in compliance with a 512(h) subpoena will be used. Can it be kept forever? Can it be used to blacklist, embarrass, market to or harass alleged infringers? The law places no real limits on how the data is used.

NOTICE AS A PRIVACY TOOL

Since we've defined "privacy" as the ability to control your personal information and how it is distributed, **notice becomes the solution** to many privacy problems.

Formal notification that they are the targets of a 512(h) subpoena would give people warning that their personal information is being given out, and put them in a position to contest wrongful subpoenas. Ideally, notice would be given both electronically and via mail by an ISP and would provide users with a meaningful opportunity to quash a subpoena that is wrongfully issued.

Notice would have a deterrent effect on abuse because 512(h) applicants would know that their targets would hear about the requests and would be able to seek court protection.

TIPS FOR INTERNET PRIVACY

We haven't discussed on-line transactions very much in this chapter because—despite what many people fear—**retail transactions with reputable on-line merchants are relatively safe**, in privacy terms. But here are some basic tips to keep in mind when doing business on the Internet:

- Know who you're dealing with. Anyone can set up shop online...sometimes in connection with a larger, reputable seller. Confirm your seller's physical address and phone number in case you have problems. **Don't reply to pop-up screens that ask for personal information.** Legitimate companies don't ask for information in that way.

- Pay by credit or charge card. If you pay by credit or charge card on-line, your transaction will be protected by the **Fair Credit Billing Act**. Under this law, you have the right to dispute charges under certain circumstances and temporarily withhold payment while the creditor is investigating them.

- Keep a paper trail. **Print and save records of your on-line transactions,** including the product description and price, the on-line receipt, and copies of every e-mail you send or receive from the seller. Read your credit card statements as you receive them and be on the lookout for unauthorized charges.

- **Don't e-mail financial information.** E-mail is not a secure method of transmitting details like your credit card, checking account, or Social Security number. If you initiate a transaction and want to provide your financial information directly through a Web site, look for **indicators that the site is secure**, like a lock icon on the browser's status bar or a URL that begins "https:"

- Check the merchant's privacy policy. It should let you know **what personal information the site operators collect**, why and how they're going to use the information. If you can't find a privacy policy—or if you can't understand it, consider taking your business to another on-line merchant.

As we've noted before, *anonymity* and *privacy* are not the same thing. Privacy is possible to maintain with some effort; anonymity, increasingly, is not. Just as you don't assume you'll be anonymous walking down the street, you shouldn't assume you'll be anonymous surfing the Internet.

One of our editors had an experience that illustrates this point. A family member wrote some disparaging things about another family member on a public Web site. While the trash-talking family member didn't name names, he used details—and an Internet handle for himself—that were **easily recognizable** by anyone who knew him. Other family

members...including the person who'd been trashed...visited the site. The trash-talker thought the Internet was so big that his nasty comments would go unnoticed. He was wrong.

Some other, more mechanical tips, for keeping your privacy on-line include:

- use an encrypted password file program to store your e-mail accounts. Use strong passwords—13 characters alpha/ numeric are about impossible to break;

- don't use the encryption program your e-mail provider supplies on its Web site. It has the key and you never know who it might will give that key to;

- clean out any "cookies" that have been installed on your computer after each session with any free e-mail service;

- keep your anti-virus software running and up to date and do full-system scans periodically;

- get an anti-spyware program (some are freeware) and do scans periodically to see if anyone is tracking your activi- ties. Frequently, off-the-shelf anti-virus programs ignore spyware programs.

These tips involve a lot of common sense. The main lesson we want to confirm in this chapter is that surfing the Internet is not a private activity. **Lots of eyes—including those of your ISP and, maybe, the government—are watching you.**

DATA MINING

In the last chapter, we considered how the FBI instructs some of its agents to gather and sort through the Internet searches of thousands of people to find suspicious activity. But **the real masters of this "data mining"** are employed by the National Security Agency (NSA)—a more secretive sibling agency...and sometime rival...of the FBI.

The term "data mining" is used a lot in privacy disputes involving the government and big corporations. What exactly does it mean? In the simplest terms, "data mining" means gathering massive volumes of data and then searching through it.

Data mining has been driven by **the exponential growth in common computing and data storage capabilities.** In fact, generic data mining tools are available for or built into most major database applications; the "sort" and "search" functions in standard programs can be used as data mining tools.

Many smart people—including some in law enforcement—believe that data mining is not a reliable tool for finding a handful of terrorists or other bad actors. These experts argue that the statistical and mathematical shortcuts needed to move from massive data to a few results make the whole process suspect...and more likely to invade innocent people's privacy than prevent disasters.

In this chapter, we'll take a look at how data mining works—or is supposed to—and how an ordinary citizen can minimize his or her chances of being sucked into a data-mining fishing expedition.

TAPPING MANY PHONE CALLS

In early 2006, the California-based Electronic Frontier Foundation filed a class-action lawsuit against AT&T Corp., accusing the telephone giant of violating the law and invading the privacy of its customers by **collaborating with the NSA in a massive program for wiretapping** and data mining the phone communications of private Americans.

The EFF suit followed from a series of reports in mainstream media outlets (including the *New York Times*) which reported that the President had authorized the NSA to intercept telephone and Internet communications inside the United States without the authorization of any court. Following from the leads offered by these media stories, the EFF was able to conclude credibly that the NSA had been intercepting and analyzing millions of

Americans' communications, with the help of phone companies like AT&T.

The EFF concluded that some companies—and AT&T, specifically—had given the NSA **direct access to their databases** of communications records, including information about whom customers had phoned or e-mailed in the recent past.

AT&T Corp. has always worked closely with the federal government. It has managed government-backed labs, cooperated with investigations and assisted in law enforcement. So, it shouldn't be surprising that the company would cooperate with questionable investigative practices.

The central claim in the EFF's lawsuit was that, by opening its network and databases to unrestricted spying by the government, AT&T had violated the privacy of its customers and the people they called or e-mailed.

Other legal groups presented with the same facts had sued the government. The EFF opted to sue the company cooperating *with* the government agencies; its theory was that a successful civil lawsuit would make it economically impossible for AT&T **to continue to give customers' personal data to investigators without a search warrant**.

As we mentioned in the previous chapter, about the same time that the EFF was suing AT&T, the California-based Internet-search giant **Google, Inc.**

was resisting similar government overtures. The Justice Department asked a federal court in California to *force* the company to turn over search records for use as evidence in a case where the government was defending the constitutionality of its Children's On-line Privacy Protection Act (COPPA).

Google had refused to comply with a subpoena for those records, based in part on its concern for its users' privacy.

COPPA is a federal law that requires companies that publish pornography and other—legal—sexual content on-line to take various steps to prevent access by minors. (COPPA is sometimes mistakenly described as an "anti-child pornography" law; in fact, it focuses on preventing kids from *seeing* adult sexual materials.)

The Justice Department was trying to establish that COPPA was an effective law. As part of this effort, the Feds had asked Google to give them a random sampling of **one million URLs** from Google's database of Web sites on the Internet. Separately— and, perhaps, more importantly—the Feds also asked Google for **the text of each search** entered into its search engine over a one-week period.

This second request was what Google considered a violation of its users' privacy.

The Justice Department justified its request by pointing out that it would **allow Google to re-**

move any information identifying the people who
entered the search terms. It told the San Jose court
that it wasn't trying to investigate individual users;
it was just trying to measure how many people
looked at what kind of pornography on-line.

Google argued that the request set a **dangerous
precedent** for government peeping into private
data. Its lawyers called the government's subpoenas
"overreaching discovery" and said that the govern-
ment was **asking Google to "do its dirty work"**
by collecting information about the activities of its
users. They also argued that—even if Google re-
moved obvious identifiers from the search results—
other bits of code could help a smart investigator
identify individual users. (These bits of code would
include markers and shortcuts like the "cookies"
that many Web sites assign to visitors.)

> **The exchange with the Justice Department high-
> lighted one point that Google would probably have
> preferred to leave alone: It keeps logs of all of the
> searches users make.**

**These logs are the perfect material for data min-
ing.** At this point, privacy groups like the EFF
started commenting on the situation. EFF staff at-
torney Kevin Bankston said:

> The only way Google can reasonably pro-
> tect the privacy of its users from such legal
> demands now and in the future is to stop
> collecting so much information about its

users, delete information that it does collect as soon as possible, and take real steps to minimize how much of the information it collects is traceable back to individual Google users.

TERMS AND STATISTICS

Data mining relies on access to large stores of data about Americans—from federal government files, state public records, telecommunications company databases, from banks and payment processors, from health care providers...and so on.

According to the federal Government Accountability Office (GAO):

> The term "data mining" has a number of meanings. ...we define [it] as the application of database technology and techniques—such as statistical analysis and modeling—to **uncover hidden patterns and subtle relationships in data and to infer rules that allow for the prediction** of future results. ...In our initial survey of chief information officers, these officials found the definition sufficient to identify agency data mining efforts.

And the GAO defines "personal information" as

> **all information associated with an individual** and includes both identifying information and non-identifying information. Identifying information, which can be used to locate or identify an individual, includes

name, aliases, Social Security number, e-mail address, driver's license number, and agency-assigned case number. Non-identifying personal information includes age, education, finances, criminal history, physical attributes, and gender.

On a more mechanical level, data mining generally falls into two subcategories:

1) **link analysis** (also called **factual data analysis** or **subject-based analysis**) is a relatively standard use of databases; and

2) **pattern-based analysis** (also called **predictive analysis**) looks for a pattern in data that has certain predetermined characteristics—including characteristics common to "normal" bad outcomes. This kind of analysis starts with conclusions and compares the evidence it finds to these conclusions.

Link analysis is, generally, the less troubling of the two types of data mining. It follows the same **deductive logic** and method that police and other investigators have used for hundreds of years; it is also subject to common sense and—in the U.S.—relatively clear Fourth Amendment limitations.

A distinguishing mark of link analysis: The **strength of the evidence** that an investigator has already gathered defines how far he or she will (or can) pursue new links.

> The biggest privacy concern raised by link analysis: A person can be considered guilty by association. In other words, anyone who comes into contact—even incidental contact—with a suspect might *become* a suspect. (Guilt by association is a recurring problem in traditional police investigations.)

Pattern-based analysis poses more problems from logical and legal perspectives; it is the problem that most privacy advocates have in mind when they talk about "data mining."

The main problem with pattern-based analysis is that it **begins with conclusions**—and reviews data in an effort to find what "fits" those conclusions. This process follows **inductive logic** which (as most college philosophy students can tell you) is subject to various fallacies. In practical terms, pattern-based analysis is susceptible to a lot of **false positives**.

Pattern-based analysis **does not begin with any particular suspicion of any specific individual.** Instead, it searches large databases in an attempt to find patterns that may indicate bad actions.

> Said another way, the conclusions with which pattern-based analysis begins are often called "hunches." Few people think that something as high-tech as data mining can boil down to trying to make facts fit someone's hunches. But it does.

Once the agency or firm using pattern-based analysis establishes its hunch, it scans massive amounts data looking for either "**conforming data**" that support the hunch or "**anomalies**" that don't. Depending on how a particular search is structured, either the conforming data or the anomalies can be the "good match" the analyst seeks.

Since either outcome can be a "good" result, whether a pattern analysis project "works" relies on another question: **What does a "match" mean?** When conforming data or anomalies have been established, what action will be taken?

THE HISTORY OF DATA MINING

It's important to point out that the origins of data mining are not in law enforcement or security...**they are in direct marketing**.

One of the earliest uses of relational databases was by direct-mail marketers using historical consumer-activity data to find patterns that they could use for refining direct-mail campaigns. The marketers **tested variables among existing customers** to determine why they had purchased certain products. Once they had found which variables were important, they could do two things:

1) sell **existing customers new products** that matched the same variables; and

2) sell **existing products to new customers** who matched the same variables.

These early efforts in data mining—often involving things like **household products**, food items

and travel packages—might have been a nuisance to some. But they provided good deals on attractive products to others. And they didn't pose much of a risk to any individual's privacy.

That all changed in the 1980s, when **credit card-issuing banks started using data-mining tools** to find profitable consumer credit risks that other issuers had overlooked. A handful of aggressive card companies had great success with data mining...and soon many more followed. Later, other financial-services providers—most notably mortgage companies—also followed.

The important change here was that the financial-services providers **mixed demographic consumer data with personal financial details**. They wanted to know where you lived, how much education you had, what kind of clothes you wore, what kind of food you ate...but also your Social Security number, your bank account numbers and your credit rating. This became a bigger privacy concern.

This combination would, in time, prove risky itself; some banks, credit card companies and mortgage lenders did a sloppy job of managing their databases. This sloppy data management drew the attention of computer hackers and identity thieves.

Still, the financial-services industry embraced data mining. They found it a cost-effective way to find new customers—what data-mining experts called "good matches."

Credit card companies also found **predictive analysis useful for uncovering relatively common abuses** and crimes, such as credit card fraud. With many thousands of examples per year, credit card networks could develop patterns of fraud based on historical data. **Their "hunches" were mathematically sound.** Finding the same patterns in current data, they could reasonably freeze certain accounts or contact customers to confirm whether certain charges were legitimate.

By the end of the 1990s, the banking and financial-services industries had not only embraced data mining, they'd been shaped by it. Several mergers between big credit card issuers were keyed to one company's more effective use of data mining.

> The government regulators and criminal investigators who worked with banks and other financial institutions followed the industries in relying on data mining for their law enforcement and oversight activities. Once they were hooked, other law enforcement agencies also embraced data mining.

Internet service providers—along with related search engines, e-mail providers and other on-line companies—also believe in data mining. Internet companies maintain vast databases that can apply to the most intimate details of your life: who you communicate with, what you read, what you buy.

Google's critics argue that keeping a log of a person's Internet searches is an invasion of that person's pri-

vacy. Legally, that argument may be weak: **Privacy has to be reasonably expected** before it can be invaded; and Google's search engine is an Internet version of a shopping mall, where lots of people may be watching what a given person does.

Google's search logs are worrisome for another reason. Information stored in a third party's database is given **much weaker legal protection** under U.S. law than data stored in the owner's computer. So, government agencies may be able to access personal information stored in Google's logs.

When marketers use historical patterns to determine who'll receive sales materials, predictive analysis can "work" even if it's wrong 95 percent of the time. However, when a government agency **uses predictive analysis to arrest and detain citizens**, the analysis won't "work" unless it's more accurate.

LOOKING FOR A "GOOD MATCH"

In other words: predictive analysis works well for common, low-impact events like credit card fraud; but it doesn't work so well with **rare, high-impact events** like suicidal terrorist attacks.

> The rarity of terrorist acts is good news in general; but it's bad news for data mining. As any actuary or risk manager will attest: When an event is rare, even an accurate predictive "hunch" will result in a high number of false positives. The rarer the event, the higher the number of false positives.

False positives aren't a problem when the "event" is selling laundry detergent. They become a problem when the event can land someone in jail for several weeks without being charged with any crime.

And the nature of predictive analysis—scanning vast volumes of data on the basis of mathematical hunches—runs against the core legal principles of due process and presumption of innocence. In the law enforcement context, a "good match" means finding a guilty party...or at least a plausible suspect. The hunches that form the basis of this kind of predictive analysis are **presumptions of guilt**.

Mixing the deductive reasoning with the inductive reasoning that makes data mining a good tool for selling laundry detergent corrupts law enforcement.

POLITICS MEETS DATA MINING

In January 2007, Senate Democrats said they would "monitor" the **privacy threats lurking in data-mining programs** created by the Bush administration.

Senate Judiciary Committee Chairman Patrick Leahy (D-VT) said he wanted to put the Bush administration on notice: Congress would no longer "stand by idly" while the executive branch continued an "unchecked explosion" in computerized sifting of huge volumes of personal information.

But Leahy said he and his colleagues were **more interested in collecting information on data min-**

ing than banning the practice. His own interest had been fueled by press reports that data mining programs like DHS's Automated Targeting System—which was originally **meant to be a cargo-screening program**—had used questionable predictive analysis tools to compile "risk assessments" on travelers to the U.S.

The Automatic Targeting System had illegally subjected tens of millions of travelers—including U. S. citizens—to invasive searches. These searches were performed on individuals without the notices required by the federal Privacy Act or the Privacy Impact Assessments required by other laws.

This was especially troubling because it had happened before. Previously, the DHS had admitted that its Secure Flight program to screen domestic air passengers violated the Privacy Act of 1974 and had abandoned that program.

And even earlier—in January 2003—the U.S. Senate had voted unanimously to restrict a Defense Department data-mining program known as Total Information Awareness, which would have linked data from sources such as credit card companies, medical insurers and motor vehicle agencies in an effort to snag terrorists. The Senate realized that the Pentagon program did more to raise privacy issues than catch terrorists.

Throughout early 2007, Leahy held a number of hearings on the subject of data mining. But most

of the testimony restated conclusions about data mining programs that had been reached several years earlier by the GAO.

DATA MINING VERSUS PRIVACY

One example of a large-scale development effort launched in the wake of the 9/11 attacks is the **Multistate Antiterrorism Information Exchange System**, also known as "Matrix." Currently used in five states, Matrix provides the capability to store, analyze, and exchange sensitive terrorism-related and other criminal intelligence data among agencies within a state, among states, and between state and federal agencies.

> **Information in the Matrix database includes criminal history records, driver's license data, vehicle registration records, incarceration records and digitized photographs. It is taken from a mix of public- and private-sector sources.**

Public awareness of Matrix and of similar large-scale data mining projects has led to concerns about the government's use of data mining to conduct mass "**dataveillance**"—surveillance of large groups of people.

Also, false positives will continue to be a problem for any program that tries to data mine for risks as remote as terrorist attacks. Any pattern-based search based on characteristics drawn from such a sample will make it difficult to **separate the "noise" of**

innocent behavior from the "signal" of terrorist activities.

What are the solutions?

To start, the federal government should **limit use of pattern-based data mining** in law enforcement and antiterrorism contexts. And it should require authorization based on a showing of effectiveness before a program is launched against U.S. citizens.

It should ensure that commercial databases accessed for data mining are subject to privacy protection. The federal Privacy Act applies to this data—whether the government is creating its own database or accessing information from a for-profit entity.

The E-Government Act of 2002 requires Privacy Impact Assessments (PIAs) if the government initiates a new "collection" of information. The same process should apply when the government acquires access to commercial databases.

Data mining will always run the risk of eroding individuals' privacy...and of generating false positives. It may be a necessary step but, as the Defense Department noted in its March 2004 report on data mining:

> even when a subject-based search starts with a known suspect, it can be **transformed into a pattern-based search** as investigators target individuals for investigation solely because of their connection with the suspect.

WHAT YOU CAN DO

Here are a few simple suggestions and things you can do to resist the effectiveness of data mining:

- protect your privacy from ISPs, Google, the government and others, by using anonymizing technologies such as Tor when surfing the Internet (more information at tor.eff.org). Tor helps hide your IP address from service providers so that—even if the lawyers come knocking—Google cannot identify you by your searches;

- give scrambled details where appropriate; e.g., your phone number if you don't want your real one on a relevant database. Encouraging enough people to do this seems likely to be easier than getting a lot of people politically active over what may seem, to non-geeks, a technical and obscure cause;

- reverse a couple of digits in your phone number or ZIP code. Sometimes, this is enough to reduce the validity of a database, and if enough people do this the corporate marketers who create rules requiring employees to collect this information will end up with unreliable and unusable data.

5

TELEPHONE
PRIVACY

When he introduced the Law Enforcement and Phone Privacy Protection Act of 2006, Texas congressman Lamar Smith said:

> Few things are more personal and potentially more revealing than our phone records. The records of whom we choose to call and how long we speak with them can reveal much about our business and personal lives....

Smith, like most Americans, assumed that **telephone calls are private activities**. This assumption is understandable, since a lot of U.S. law is focused on regulating how the government and private parties can "listen in" on private phone calls.

U.S. Supreme Court Justice Louis Brandeis' famous quote about **privacy being the "right to be left alone"** was part of a telephone wiretapping decision (*Olmstead v. United States*).

However, in recent years, technology and terrorism have combined to **erode the privacy of phone calls**. You won't find a single court decision that says this plainly; but the effect has been real.

Phone calls have stronger privacy protection under U.S law (and in most developed countries) than Internet use does; but they aren't as private in the 2000s as they were in the 1980s...or even the 1990s.

> Government surveillance has played a big part in this erosion; but it's not only a Big Brother factor. Private-sector entities have been listening in, too. And, surprisingly, even some of the big telephone companies have cooperated—which may lead, eventually, to the erosion of their markets.

So, we'll start our discussion of telephone privacy with one of the things private-sector parties do to make telephone calls less private.

PRETEXTING

In April 2007, the Federal Communications Commission approved **a series of privacy rules** that included requiring a password for a consumer to access account information from his or her telephone company. The rules were created to safeguard against *pretexting*—the practice of impersonating a person to gain access to his or her phone records.

The FCC rules were drafted in response to the **Hewlett-Packard pretexting scandal**, which had drawn a lot of public attention the previous fall.

H-P chairwoman Patricia Dunn had been frustrated by a series of leaks to the media about the company's long-term market strategy. She believed that the

source of these leaks was someone on the H-P board of directors. In early 2006, she hired a team of "independent electronic-security experts" to help determine who was talking to the press.

> The "experts" spied on H-P board members and several journalists to determine the source of leaks. And they were not subtle. The tactics they used—including pretending to be specific board members in order to get personal call records from phone companies—were easily discovered.

The "experts" also used pretexting to get phone records of journalists working for publications such as the *New York Times* and the *Wall Street Journal*.

The tactics worked. Using the phone records, the "experts" were able to determine that H-P board member George Keyworth had been in contact with reporters at key times when news about the company was being published.

Dunn tried to use the information against Keyworth—but underestimated how angry the rest of the directors would be when they learned that *their* phone records had been accessed without their permission and under false pretenses.

The directors didn't fire Dunn immediately; but they agreed to go public with the story in order to create "transparency" about the matter and mitigate any legal or public relations problems. One of the steps they took was to file SEC documents that

described the situation and noted that it could affect the company's operations.

In the media coverage that followed, Dunn claimed weakly that **she didn't know the methods her "experts" had used were illegal**. In general, her unapologetic demeanor smacked of what one magazine called "peculiar logic" and created the impression that she had been in over her head as the senior executive of large corporation.

In September 2006, the House Committee on Energy and Commerce wrote Dunn, stating that it was conducting an investigation on Internet-based data brokers who used **"lies, fraud and deception" to acquire private information** including "itemized incoming and outgoing call logs." It invited her to testify about what she'd done. This was embarrassing to the company. But **Dunn agreed to testify** to Congress later that month.

The next day, H-P announced that Keyworth—the original leaker—resigned from the board and that Mark Hurd, the company's CEO and president, would replace Dunn as Chairman after the regular board meeting in January 2007.

But public outrage continued. California Attorney General Bill Lockyer said his office was considering criminal charges against Dunn and others. A few weeks later, Hurd announced at a special press briefing that **Dunn had resigned effective immediately** as both Chairman and director.

Dunn, Hurd and other H-P executives were scheduled to testify before Congress about the pretexting

on September 28. During her testimony, Dunn said that she had not known that pretexting could involve **identity misrepresentation**. She repeatedly insisted that she'd believed personal phone records could be obtained through legal methods. Many observers found her testimony unconvincing.

> Apparently, the California Attorney General was one of those. On October 4, Lockyer filed criminal charges and issued arrest warrants against Dunn, a former H-P lawyer and three outside investigators. (He also filed civil charges against H-P for allowing the "rogue investigations" to be made.)

In December 2006, H-P paid $14.5 million to settle the civil charges brought by California Attorney General Lockyer. The criminal case against Dunn and the investigators continued.

THE FCC RESPONDS

FCC Chairman Kevin Martin said that his agency's April 2007 rules took "a strong approach to protecting consumer privacy." This was a reference to the **consumer issues raised by the H-P scandal**.

In addition to the **password protection**, the rules required carriers to ask for customers' permission when sharing private account information with business partners and independent contractors.

Phone companies had argued that such an "opt-in" requirement violated their First Amendment right

to communicate with customers—a position approved by a federal court in 1999. But the public outrage over the H-P case blunted those arguments.

Earlier in 2007, George W. Bush had signed a law **criminalizing pretexting and imposing penalties, including up to 10 years in prison**. The law gave police a weapon to punish perpetrators but left out requirements on how phone companies should protect their customers' private information.

> **When the Bush Administration opposes a surveillance technique, you can be sure it's trouble—because the Administration embraces most forms of surveillance.**

TELECOMS AND CUSTOMER DATA

The April 2007 rules were significant because the FCC doesn't have a strong history of **pressing phone companies to protect customer privacy**. Historically, it has stood by as telecoms cooperate with government programs that *erode* privacy rights.

In May 2006, the federal government wanted a case brought against AT&T by the Electronic Frontier Foundation dismissed on the grounds of military and **state secrets privilege**.

The Justice Department filed a "statement of interest" with the court overseeing the EFF's lawsuit against AT&T. That statement came in requests by the EFF for information about data-mining pro-

grams it believed were being run at AT&T data centers, absorbing details on all communications that passed through—in violation of the First and Fourth Amendments and various laws.

News of these programs had become public after a technician named Mark Klein claimed to have helped install equipment related to the alleged spying activities. Klein said that details on phone calls passing through one AT&T switching facility were collected by powerful data-mining computers that NSA employees could access.

> As we've noted before, AT&T has a long history of cooperating with the government on defense and national security projects.

This NSA program was far more expansive than anything the White House had acknowledged. In 2005, George W. Bush said he'd authorized the NSA to eavesdrop—without warrants—on *international* calls and e-mails of people in the U.S. who were suspected of having links to terrorists. In defending that program, Bush said, "one end of the communication must be outside the United States."

If the EFF's version was right, the NSA domestic program violated the spirit and letter of Bush's statement. With the details of billions of domestic calls, the NSA had a big window into the private lives and personal habits of millions of Americans.

> And the NSA might have more than that. The phone numbers it was collecting could easily be cross-checked against commercial databases to obtain names, addresses and other personal information.

The domestic program wasn't new. According to the EFF, it had begun soon after the 9/11 attacks. Around that time, NSA representatives approached the big telecoms with urgent pitch: "National security is at risk, and we need your help to protect the country from attacks."

THE LAW SAYS "NO"

Federal law is pretty clear that **the phone companies should have said "no" to the NSA** pitch.

Under Section 222 of the Communications Act, first passed in 1934, telephone companies are prohibited from giving out information regarding their customers' calling habits: whom a person calls, how often and what routes those calls take to reach their final destination. **Inbound calls, as well as wireless calls, also are covered.**

The financial penalties for violating Section 222 can be stiff. The FCC can levy fines of up to **$130,000 per day per violation**, with a cap of $1.325 million per violation.

But, according to the EFF, the NSA said that it was willing to pay telecoms for their cooperation. This implied indemnification against fines and other le-

gal actions. With that, the NSA's domestic program began in earnest.

> The NSA's domestic and international call-tracking programs apparently had many operation details in common. Both were conducted without warrants or the approval of the FISA "secret" court.

This last point didn't surprise many privacy advocate. The Bush administration had argued that FISA procedures were too slow for effective response to terror threats. Administration officials—most notably, the Attorney General—had claimed that the USA Patriot Act gave it **broad authority to act preemptively to protect national security**. And the AG had testified that he "wouldn't rule out" operating domestic telephone surveillance programs.

QWEST FIGHTS BACK, SOME

According to the EFF, among the big telecommunications companies only Qwest refused to cooperate with the NSA. Qwest declined to participate because it was uneasy about **the legal implications of handing over customer information** to the government without standard warrants.

Qwest's hesitance left the NSA with a hole in its database. But AT&T and Verizon provides some services—primarily long-distance and wireless—to people Qwest's West and Northwest regions; and, since AT&T and Verizon were cooperating with the NSA, they could help make the hole smaller.

Qwest management was troubled by the NSA's assertion that it didn't need a court order or approval under FISA to proceed.

Qwest was also unclear about who, exactly, would have access to its customers' information. At one point, Qwest's CEO said he was concerned about the "disinclination on the part of the authorities to use any legal process."

Qwest's lawyers asked NSA to take its program to the FISA court for clarification. That never happened—apparently because the NSA didn't want the FISA court ruling against the domestic call-tracking program.

THE EFF LAWSUIT MOVES ALONG

So, the EFF lawsuit against AT&T would be the first legal consideration of the program. Along the way, the EFF expanded its action with suits against BellSouth and Verizon.

According to the EFF:

> ...besides actually eavesdropping on specific conversations, NSA personnel have intercepted large volumes of domestic and international telephone and Internet traffic in search of patterns of interest, in what has been described in press reports as a large "data mining" program.

The lawsuit alleged that AT&T had installed—or assisted government agents in installing—interception devices like pen registers and trap-and-trace devices on or in a number of its key telecommunications facilities.

Pen registers and trap-and-trace devices capture, record or decode the dialing, routing, addressing and/or signaling information (in telecom jargon, "DRAS information") for phone calls.

> Government investigators like those devices precisely because they don't record conversations or e-mail content; so, they generally stand up to court scrutiny better than recordings do.

AT&T's databases were an impressive collection of information. According to the *Los Angeles Times*:

> AT&T has a database code-named Daytona that keeps track of telephone numbers on both ends of calls as well as the duration of all land-line calls.... After Sept. 11, intelligence agencies began to view it as a potential investigative tool, and the NSA has had a direct hookup into the database....

As of September 2005, the call data managed by the Daytona system, when decompressed, totaled more than 312 terabytes.

Daytona's speed and power allowed users to search the entire contents of a database quickly and easily. For example, a Daytona user could query the data-

base for all calls made to a particular country from a specific area code during a specific month—and **get details on all such calls in about a minute.**

Daytona also managed AT&T's huge network-security database, known as Aurora, which stored **Internet traffic information.** The Aurora database contained huge amounts of data acquired by firewalls, routers and other devices on AT&T's global Internet Protocol (IP) network.

The EFF argued that AT&T customers had a **reasonable expectation of privacy** in their communications and records pertaining to their communications that had been collected and made accessible to the NSA by AT&T—acting as an instrument or agent of the government.

> **As predicted, the Justice Department moved to have the case dismissed because, to litigate the case, "it may be [necessary] to disclose state secrets."**

In July 2006, a federal judge in California rejected the Justice Department's requests to dismiss the EFF suit. Judge Vaughn Walker wrote:

> Because of the public disclosures by the government and AT&T, the court cannot conclude that...this action creates a "reasonable danger" of harming national security.

The judge also rejected AT&T's request to dismiss the case on technical grounds. AT&T had argued

that it was entitled to various forms of "immunity" from prosecution because:

> telecommunications carriers should not be subject to civil liability for cooperating with government officials conducting surveillance activities. That is true whether or not the surveillance was lawful, so long as **the government officials requesting cooperation assured the carrier that it was**.

Walker rejected those arguments, saying the company could not "seriously contend that a reasonable entity in its position could have believed that **the alleged domestic dragnet was legal**."

On the issue of **state secrets**, Walker wrote:

> [T]he first step in determining whether a piece of information constitutes a "state secret" is determining **whether that information actually is a "secret."** ...It is not a secret for purposes of the state secrets privilege that AT&T and the government have some kind of intelligence relationship.

The judge didn't comment on the irony of a telecom company **demanding privacy for its actions while invading the privacy of its customers**.

A *REALLY* STUPID LAWSUIT

At the same time the Justice Department was fighting hard in San Francisco to justify the NSA's invasion of citizens' privacy, it was fighting just as hard in a New Jersey court to keep the NSA's own activities... well, private.

In May 2006, Anne Milgram, the Attorney General of New Jersey, started an investigation into whether telecom companies providing service to subscribers with a New Jersey billing address or telephone number had disclosed Telephone Call History Data to the NSA.

Subpoenas were issued pursuant to New Jersey Consumer Fraud Act to 10 telephone carriers. The Subpoenas sought:

1) all orders, subpoenas and warrants pursuant to which the Carriers were requested to furnish Telephone Call History Data;

2) an identification of the persons whose Telephone Call History Data was provided to the NSA;

3) a sample of the contract or other form agreement with subscribers which addresses the Carriers' authority to disclose subscriber information to third parties and any obligations prior to such disclosure; and

4) all documents concerning any communication between the Carriers and New Jersey subscribers concerning the NSA request for Call History Data.

The Subpoenas required the Carriers' responses on or before May 30, 2006.

Before Milgram could initiate any state enforcement action, **the Feds sued her**—as well as the Director of the New Jersey Division of Consumer Affairs and

the Deputy Attorney General who'd signed the Subpoenas—in federal court.

Five of the subpoenaed telecoms—AT&T, Verizon Communications, Qwest, Sprint/Nextel and Cingular Wireless—were **also named as defendants**. The Justice Department sought a declaratory judgment that the state subpoenas could not be enforced by New Jersey officials or responded to by the companies because

> any attempt to obtain the information that is the subject of the Subpoenas would be invalid under, preempted by, and inconsistent with the Supremacy Clause... federal law, and the Federal Government's exclusive control over foreign intelligence gathering activities [and] national security....

Effectively, the Feds were asking the court to stop the New Jersey Attorney General from carrying out her responsibility to investigate violations of **her state's consumer protection laws**.

The federal judge refused to do that, writing:

> ...The [state secrets] privilege is not an independent basis upon which to authorize the federal court effectively to enjoin state officials from executing their official duties. The privilege is **a court-created rule of evidence**, not a substantive federal right. ...[The Justice Department]'s distorted interpretation of the privilege would effectively immunize federal executive action from judicial scrutiny.

The ruling was a rebuke of the Feds' efforts to use "state secrets" claims to **justify their privacy-invading actions**.

In this context—and many others—the **courts are an essential protector of privacy**, keeping a careful eye on "federal governmental action that threatens or seeks to thwart fundamental liberties."

The New Jersey judge also echoed the California federal judge's conclusion in the EFF lawsuit:

> ...The existence of the telephone records surveillance program is **already a matter of public record**; therefore, compliance with the Subpoenas is not prohibited by the state secrets privilege.

And the New Jersey Attorney General's initial concern was validated: Disclosure of telephone calling records without a court order and without notice to the people whose private information was being disclosed could violate New Jersey consumer protection statutes.

The New Jersey case followed an interesting theory—that the state's consumer protection laws could serve as a legal tool for maintaining privacy. This may not work in every state...but it's worth investigating, wherever you live.

6

DATA BROKERS— THE INVISIBLE PRIVACY THREAT

Most people assume that the biggest threats to their **personal and financial privacy** are criminals who might steal their purses or wallets...or high-tech thieves who might hack into their computers. In fact, the biggest threat to your personal privacy might be a company you've never heard of with a newfangled name like CardSystems Solutions, ChoicePoint or Acxiom.

> Assembling and distributing personal data is a profitable and fast-growing business. Banks, mortgage companies, insurance companies, landlords, employers and government agencies all want detailed information on people—but they don't want the liability of holding all of that data. So, they contract the job to outside companies.

Data brokers—those outside companies—are the one you need to watch. Data brokers assemble names, addresses, property records and other public information for use by everyone from employers to law enforcement agencies.

With a patchwork of state laws on data handling in place, ordinary citizens face more risks from data brokers than they realize. The brokers use consumer information but work for corporate clients; this **divided loyalty** creates opportunity for thieves.

Why do big companies use outside data brokers? Because the cost of keeping customer data—and not protecting it—can be very high. The experiences of the retailer TJX Companies prove this point.

TJX owns the clothing-store chains T.J. Maxx and Marshalls. Beginning in early 2005 (no one's sure exactly when), a group of identity thieves hacked into TJX's corporate computer network and located valuable customer information. The hacks continued for at least 18 months—until TJX reported the problem in a January 2007 filing with the Securities and Exchange Commission.

> **The ID thieves concentrated on tracking data exchanged during the credit or debit card authorization process. TJX transmitted unencrypted consumer information to card issuers who would send back answers about whether charges had been approved or declined. The thieves set up a program to copy the unencrypted data from TJX.**

The ID thieves stole names, addresses, credit card numbers and other information useful to setting up "clones"—fake versions of real people that can be used to open new credit accounts, bank accounts and borrow money. But details were hard to estab-

lish. How many names had the crooks stolen? How many credit card numbers? No one was sure; but TJX estimated that **45 million credit and debit card numbers had been exposed**.

In April 2007, the Massachusetts Bankers Association announced that it was being joined by at least two other state bank groups in a class-action lawsuit seeking "tens of millions of dollars" from TJX for the breaches it allowed to go on for so long. The Massachusetts group was looking for other state banking organizations to join its lawsuit.

According to the Association, banks throughout New England were continuing to receive lists of "hot cards" that had been exposed in the TJX data breach—more than three months after TJX had disclosed the problem.

IS MORE LAW THE SOLUTION?

Politicians have tried to regulate commercial use of personal information. But these efforts have had little real success.

In January 2007, U.S. Senator Dianne Feinstein reintroduced a series of bills to increase government **oversight of companies that keep personal data**. (Earlier versions of the bills had died "in committee" before reaching the congress for votes.)

Feinstein's proposals aimed to do two things:

1) set national requirements for consumer notification in the event of data security breaches, similar to existing state

laws in California and a few other locations; and

2) restrict the sale, purchase and display of Social Security numbers.

Under Feinstein's **Notification of Risk to Personal Data Act**, any federal agency or business that "uses, accesses, transmits, stores, disposes of, or collects sensitive personally identifiable information" would be required to notify "without unreasonable delay" any U.S. resident whose data may have been compromised by a security breach. The bill prescribed methods of notification and dictated what information those notices had to contain.

Feinstein's second bill, called the **Social Security Misuse Prevention Act**, prohibited the sale, purchase or "display"—defined as any intentional communications to the general public, including via the Internet—of Social Security numbers without "affirmatively expressed consent of the individual," either electronically or in writing.

The second bill surprised some observers—who weren't aware that private-sector data brokers were allowed to sell individual Social Security numbers.

This Act created steep criminal and civil penalties for anyone using Social Security numbers to locate individuals and do them harm; it also **limited use of Social Security numbers on federal documents** and in consumer transactions.

> **Why hasn't the federal government done more to regulate data brokers before Feinstein's bills? Because it's one of their biggest customers.**

The U.S. federal government has been buying information from private data brokers for many years. In January 2002, the Electronic Privacy Information Center (EPIC) asked a federal court to order the disclosure of records regarding the sale of personal information to law enforcement agencies. EPIC claimed that the Departments of Justice and Treasury—as well as several other agencies—had failed to respond to a series of **Freedom of Information Act** (FOIA) requests. The requests sought records relating to "transactions, communications, and contracts" between law enforcement agencies and private firms engaged in the sale of personal data.

EPIC made the FOIA requests in the wake of a lengthy article in the *Wall Street Journal* which reported that Georgia-based data broker ChoicePoint had routinely sold personal information to federal law enforcement agencies.

According to EPIC's FOIA lawsuit:

> On April 13, 2001, the *Wall Street Journal* reported that executive branch agencies were purchasing "troves of personal data from the private sector."
>
> ...The use of private sector databases of personal information enables the government to obtain detailed information on citizens

while **avoiding the creation of files** that would implicate protections provided under the Privacy Act of 1974.

Eventually, the government agencies provided EPIC with the memoranda and other documents that it requested. Those documents showed that ChoicePoint and Experian (another data broker) had sold the Treasury Department's Internal Revenue Service so-called "**credit header data,**" property records, state motor vehicle records, marriage and divorce data and international asset location data.

ChoicePoint had been particularly "helpful." It created a special federal government "Web portal" (since disabled) at www.cpgov.com that gave IRS employees **direct access to citizens' personal data.**

SHADOWY DATA DEALS

Despite the best efforts of groups like EPIC to **shed light on the government's dealings with private-sector data brokers,** most of the deals have remained shadowy. In many cases, dealings between government agencies and private-sector, for-profit data brokers are clearly designed to evade the requirements of the **Privacy Act of 1974.**

That law states:

> No agency shall disclose any record which is contained in a system of records by any means of communication to any person, or to another agency, except pursuant to a written request by, or with the prior written consent of, the individual to whom the record pertains....

> Each agency that maintains a system of records shall...upon request by any individual to gain access to his record or to any information pertaining to him which is contained in the system, permit him...to review the record and have a copy made of all or any portion thereof in a form comprehensible to him [and] maintain in its records only such information about an individual as is relevant and necessary to accomplish a purpose of the agency....

The Privacy Act goes into greater detail about how government agencies must limit the data they hold on individuals, must make such data available for review by each individual and—if an individual disagrees with the accuracy of that data—must respond to that disagreement.

So, many government agencies have concluded that it makes more sense to outsource the "holding" of personal data to private-sector firms. The enforcement of rules like the Privacy Act is less stringent on those outside firms.

That's why policy-makers have slowly started to turn their attention to data brokers. And Dianne Feinstein isn't the only one.

In early 2007, two *other* U.S. Senators—Pennsylvania Republican Arlen Specter and Vermont Democrat Patrick Leahy—revived a version of their Personal Data Privacy Act that had been approved by the Senate Judiciary Committee in 2006 but died before a floor vote.

Specter and Leahy had first proposed a broader version of the measure in 2005 after word of high-profile breaches at the big data brokers ChoicePoint (a corporate sibling of the better-known credit reporting agency Equifax) and LexisNexis.

The Specter-Leahy bill would impose **fines, up to five years in prison, or both for those who intentionally conceal information** related to a security breach that causes "economic damage to one or more persons." And—perhaps most importantly— it would also place the **same requirements on private-sector data brokers that the Privacy Act place on government agencies.** They would have to allow consumers to view all records about themselves that are on file and make corrections.

At the same time that Specter, Leahy and Feinstein were promoting their bills in the U.S. Senate, a number of similar bills were being presented in the House of Representatives.

Facing all of this increasing scrutiny and review, private-sector data brokers went on the offensive— in political circles and in the public media. The PR blitz was especially noticeable.

In April 2007, *USA Today* published a long article on ChoicePoint's "remarkable turnaround" from sloppy bumbler to privacy champion.

The article stated that ChoicePoint, "the giant data broker excoriated two years ago for its lack of precautions as it went about gathering and selling personal data, has recast itself as a model corporate citizen." It went on to note:

> The once-obscure data broker, tucked away in a nondescript business park 20 miles north of Atlanta, also embraced extensive reforms. The result: ChoicePoint is regarded by...leading privacy advocates...as the most responsible company among dozens in the **lightly regulated, fast-growing field** of aggregating and selling sensitive information.

ChoicePoint had beefed up credentialing of customers and expanded an on-line service that let people view their own records and make corrections. It had also exited the profitable business of selling Social Security numbers, birth dates and driver's license numbers to private detectives, collections agencies and other small-time clients.

Many industries talk about "self-policing" when they fear that the government will change laws or create laws that make *real* policing a possibility.

Privacy advocates worry that self-policing isn't enough; only a portion of what data brokers do falls under the federal Fair Credit Reporting Act, which regulates how the so-called "Big Three" data brokers (Equifax, Experian and TransUnion) collect and disseminate consumer credit information.

Other data brokers (including companies with **corporate ties to the Big Three**, as ChoicePoint has with Equifax) argue that much of what they disseminate is not covered by federal rules because it is based on public records—such as birth and death certificates, and property records. Technically, this is true. But these distinctions are **a classic example of a conflict between the letter and the spirit of credit reporting laws**. When a big credit agency creates a corporate sibling that it spins off as a "separate" company, not bound by the Fair Credit Reporting Act and other laws, it is perverting the intent of the consumer-protection law.

> **Technology advances in data storage have allowed data brokers to twist the intent of credit-reporting laws. The government compels individuals to reveal their personal information in a variety of contexts, then pours it into the public record for anyone to use. Data brokers collect the information, repackage it and return it back to the government.**

Data broker executives repeat standard company lines about how their mission is to help companies and government agencies "manage risks." They have less to say about helping individual consumers manage *their* risks if ID theft and other frauds.

ChoicePoint isn't the only data broker that has lots of information on you...and a mixed record of protecting that information. Its main competitors in the unregulated end of the data brokering business are Arkansas-based **Acxiom Corp.** and several

units of the United Kingdom-based media conglomerate **Reed Elsevier** Group, plc.

Acxiom describes itself as specializing in the tracking and use of "life-style data"—information about the reading and voting habits of consumers culled from public records and consumer surveys. And it is true that Acxiom doesn't specialize in credit information as other data brokers do. But, clearly, many of its "**life-style data services**" use other criteria to accomplish the same end: grouping people into demographic categories, often based on how much they can or will spend.

LexisNexis, a major unit of Reed Elsevier, handles most of the conglomerate's data brokering business in the U.S. Like Acxiom, LexisNexis doesn't handle credit histories *per se* but tracks other personal information. And, like ChoicePoint, it has **had some major security problems**.

In the Spring of 2005, Reed Elsevier and LexisNexis admitted that hackers had accessed more than 300,000 personal data files held by their **Florida-based unit Seisint**. The hackers got names, addresses, Social Security numbers and drivers' license numbers. This was exactly what ID thieves needed.

As in the TJX case, the Seisint hackers had been in the company's computer systems for more than a year. They'd steal log-in information belonging to "legitimate" Seisint customers (in many cases, law enforcement agencies) and then access the broker's large databases of personal information in ways that legitimate customers wouldn't. Seisint's legitimate customers usually **accessed its databases to find**

additional information about an specific individual; the hackers were interested in "wholesale" information on everyone in the system.

Seisint had started out as an independent company. Reed Elsevier had acquired Seisint because of its involvement in the Multi-state Antiterrorism Information Exchange System (known as "Matrix"), a government-funded crime and terrorism database project. The big conglomerate wanted to be involved in that project. Soon after the 2005 admission of the hacks into the other Seisint databases, Reed Elsevier dissolved Seisint and integrated its operations into existing LexisNexis departments.

When asked about data security after the Seisint breaches, a LexisNexis spokeswoman said the company was "confident that our security procedures are **as robust as others in the industry**." That statement seemed to ignore the fact that industry standards were troublingly low.

Marketplace pressures on data brokers aren't likely to make their databases more secure. Newer data brokers—such as ZabaSearch, Intelius and PrivateEye.com—are pressuring established brokers to make more information available to more buyers. The newer players typically sell detailed personal information on individuals to anyone who can provide a credit card number.

Intelius is a good example of the newer data brokers. Its marketing focus is on consumers who want

to run inexpensive background checks on baby-sitters, day-care providers, coaches, etc. Its databases include public information on arrests, convictions, sex crime registrations, civil lawsuits, bankruptcies, divorces and residential histories.

> **The breadth of the Intelius databases would be attractive to hackers looking for ID theft material, just as the Seisint databases were.**

KEEP SAFE FROM DATA BROKERS

The hard truth is that there's practically **no way to prevent data brokers from collecting your personal information**. Even if you pay cash and borrow little, the chances are that you leave some "footprint" from the job you work, the taxes you pay or other public documents your life generates.

We suggest that you check your credit reports from each major credit bureau once a year—and aggressively **correct any mistakes** that you find in that. The information that data brokers have usually flow from the "Big Three" credit bureaus.

On the next few pages, we offer **some sample letters that you can use** to put together your written correspondence with data brokers. When sending these letters, use Certified Mail/Return Receipt or equivalent service. You will want to keep proof of the letters being delivered.

CREDIT BUREAU DISPUTE LETTER

(Your Full Name)
(Street Address),
(City, State & Zip)

(Credit Reporting Agency)
(Address)
(City, State & Zip)

Date:
Account Number(s):
Re: Credit Reporting Agency Disputed Item

To Whom It May Concern,

Your company is reporting what I believe to be inaccurate data. This letter serves as formal notice that I dispute the data (which I describe in detail below). Your company is governed by the **Fair Credit Reporting Act** (FCRA), which protects consumers from inaccurate, outdated or invalidated information reporting of their credit file.

The FCRA states that it is your responsibility to ensure that all information contained within consumer credit files is accurate and free from errors.

Because your company has allowed this inaccurate information to be reported on my credit file, I have suffered various damages—including: being denied credit, being forced to pay additional fees for financial services and being embarrassed and humiliated in public settings.

In the course of investigating these matters, I have contacted the collection agency or the original credi-

tor related to each inaccurate item and asked for supporting documentation. Among other things, I asked for evidence that I was given the required 30-day notice to dispute the validity of the debt.

The FCRA, 15 U.S.C. Section 1692g(a), mandates that a debtor has 30 days to dispute the validity of a debt. If the creditor cannot provide sufficient evidence that the debtor was given adequate notice, the debtor must be given another 30-day period to review the alleged debt—and the creditor must provide evidence that the debtor is liable for the account(s) in question.

I've sent several notices to the creditors or collection agencies requesting validation of the account(s) below; they have failed to provide adequate documentation proving my liability or obligation. Therefore, I dispute these debts and request the following items be deleted from my credit report:

(Name of Creditor), Basis for Dispute, (Account Number), (Amount)

(Name of Creditor), Basis for Dispute, (Account Number), (Amount)

(Name of Creditor), Basis for Dispute, (Account Number), (Amount)

(Name of Creditor), Basis for Dispute, (Account Number), (Amount)

(Name of Creditor), Basis for Dispute, (Account Number), (Amount)

If you do not delete these items within 30 days of receipt of this notice, please send me a complete description of the procedures used to determine the accuracy of the account(s) I am disputing—as well as the name and contact information of the agent conducting said investigation in case further communication is necessary.

Sincerely,

(Signature)

DISPUTE FOLLOW-UP LETTER

(Your Full Name)
(Street Address)
(City, State & Zip)

(Credit Reporting Agency)
(Address)
(City, State & Zip)

Date:
Account Number(s):
Re: Credit Reporting Agency Disputed Item

To Whom It May Concern,

I sent you a dispute letter on (Date of Dispute Letter), which was signed for on (Date Received). However, it's been more than 30 days and you have not responded. This is my formal follow up notice.

Your company is allowing inaccurate information to be reported on my credit file. Pursuant to the FCRA, you are required to verify disputes within 30 days, but as of (Date Received), you have not done so or responded to any of my correspondence.

Therefore, I am requesting that **the following items on my credit report be deleted** immediately:

(Name of Creditor), Basis for Dispute, (Account Number), (Amount)

(Name of Creditor), Basis for Dispute, (Account Number), (Amount)

(Name of Creditor), Basis for Dispute, (Account Number), (Amount)

Upon completion of your investigation, please send an updated copy of my credit report showing the above items deleted—as well as the name and contact information of the agent conducting this case if any additional information is necessary. If no confirmation is sent, I will assume the person signing for the letter is responsible for any failure to comply and this person may be named along with your company in actions that I take to recover the damages your company has caused me.

I reserve the right under [state] Law to record any incoming conversations and I have no further obligation to advise you that they are being recorded.

Sincerely,

(Signature)

CHAPTER

7

PRIVACY &
GOVERNMENT
AGENCIES

Although a right to privacy is strongly implied by the U.S. Constitution, government agencies are very poor protectors of privacy. And, as we've seen already, agencies like the FBI and the NSA show an active disdain for individual privacy.

One of the main things that government agencies do is hold a lot of personal information in databases (even though they try to outsource some of this data management to private-sector companies). So, one of the main things they might do to protect individual privacy is make sure those databases are secure. They don't do this well.

A report released in the Spring of 2007 by the White House Office of Management and Budget (OMB) gave the federal government an overall grade of *C-minus* for securing its computer systems and networks from hackers, viruses and insider threats during 2006. This was a slight improvement from its performance the previous year.

Among the government agencies that scored failing grades from OMB were the Departments of **Agriculture, Commerce, Defense, Education,**

Interior, State and Treasury—as well as the Nuclear Regulatory Commission. The Department of Homeland Security earned a D.

> The Department of Veterans Affairs, which made news in 2006 for "losing" the personal financial details of millions of veterans, did not provide enough data to earn a grade for 2006 (in 2005, it had received an F).

The OMB grades were based on how well agencies met the requirements detailed in the 2003 Federal Information Security Management Act (FISMA).

> That law requires agencies to meet a several computer security standards, ranging from operational details—such as ensuring proper password management by workers and restricting employee access to sensitive networks and documents—to creating procedures for reporting security problems.

The biggest and clearest example of government mishandling of personal data came in May 2006, when the Department of Veterans Affairs announced that a laptop and external hard drive containing detailed personal information on 26.5 million veterans had been stolen from an employee's home.

The personal data on the computer included names, birth dates, Social Security numbers, complete

addresses and telephone numbers of veterans—and some active military personnel. The employee had broken various Department policies by taking the information to his suburban Maryland home; apparently, he had been doing so for some time before the laptop was stolen.

> **The problem didn't come as a complete surprise: The VA's Inspector General had been warning each year since 2001 that the Department's information security systems were inadequate.**

The VA found itself in even more trouble when news got out that its **executives had waited nearly three weeks to announce the laptop theft**. The employee who'd taken the computer home reported the theft to his supervisors soon after it happened on May 3. Apparently, they kept quiet, hoping that the stolen laptop would be recovered quickly and they wouldn't have to explain the exposure.

Things didn't go as they'd hoped.

About a week later, members of VA Inspector General George Opfer's staff **heard about the theft through "informal channels"**—that is, office gossip. They began to ask questions.

But the bureaucracy *still* moved slowly. VA Secretary Jim Nicholson didn't learn about the stolen computer until May 16. **His office immediately went public with the information.**

Nicholson fired the employee who'd taken the laptop home; and he accepted the resignation of the employee's boss—a deputy assistant secretary.

The laptop and external hard drive were eventually recovered by Maryland police in late June, about eight weeks after the theft occurred. FBI forensic data specialists examined the machines and **concluded with reasonable certainty that the data had not been accessed**. The thieves may have not understood the value of what they'd stolen.

Still, the VA faced harsh criticism from politicians and angry veterans.

A coalition of veterans groups filed a lawsuit against the VA, arguing that their members' privacy rights had been violated. The suit sought $1,000 in damages to each affected person—up to $26.5 billion in all. The veterans also asked for a court order barring VA employees from using sensitive data until independent experts could determine proper safeguards. According to the lawsuit:

> VA arrogantly compounded its disregard for veterans' privacy rights by recklessly failing to make even the most rudimentary effort to safeguard this trove of the personally identifiable information from unauthorized disclosure.

The suit cited various sections of the federal **Privacy Act**, which generally requires government agencies to have protections to prevent the unauthorized disclosure of personal information.

CHAPTER 7: PRIVACY & GOVERNMENT AGENCIES

THE VA ISN'T THE ONLY PROBLEM

Throughout 2006, while the VA was getting most of the bad press, the Internal Revenue Service was wrestling with similar problems. **And the IRS problems may have been more system-wide than the VA's.**

According to a report released in early 2007 by IRS Inspector General J. Russell George, the agency put thousands of taxpayers at risk of identity theft or other financial fraud because **it had failed to protect information** some 52,000 laptop computers and other data storage systems.

> The Inspector General stated that the IRS did not begin to correct the security problems until the second half of 2006, despite being warned about them in 2003 and again in February 2006. In the meantime, nearly 500 IRS laptops had been lost or stolen. One IRS laptop would usually contain detailed files on between 10 and 25 tax cases.

Although the missing laptops could not be examined, the Inspector General's staff randomly tested 100 laptops used by IRS employees and found 44 contained "unencrypted sensitive data, including taxpayer data and employee personnel data," leading investigators to conclude "it is very likely **a large number of the lost or stolen IRS computers contained similar unencrypted data.**"

No taxpayers had been alerted to the potential security breaches, IRS officials said. But they also argued that not cases of identity theft had been connected directly to IRS computers.

The Inspector General's report noted that the security problems weren't limited to laptops. It identified similar security holes in backup systems at IRS field and processing offices around the country. In one instance, "an employee wrote user account names and passwords to the computer and various systems to which the employee has access on a piece of paper that was taped to the laptop."

The privacy problems aren't only on the federal level. State and local government agencies are also bad at protecting personal information.

In March 2007, a privacy advocate drew media coverage when she said that she'd publicize the names of well-known Massachusetts residents whose **Social Security numbers and personal data she'd been able to download** from a state Web site.

The advocate, Virginia-based writer Betty Ostergren, also said she'd post detailed **instructions on how to access the data from the Massachusetts site**. Ostergren had built a reputation and following on the Internet by pointing out examples of how state agencies mishandle private information.

In the case of the Massachusetts Web site, Secretary of State William Galvin had refused to **take down**

the records or redact (that is, "black out") the personal details—despite being told they posed a potential risk to individuals' privacy.

A spokesman for Galvin's office argued that the bulk of the on-line documents were business filings. Only about five percent were believed to include individuals' Social Security numbers. The Secretary of State's office had removed Social Security numbers from more recent postings—and anyone who believed his or her records contained Social Security numbers was free to request that they be removed.

> In other words, victims were free to ask the commonwealth to stop harming them. Until they asked, it would keep doing so.

INTENTIONAL EXPOSURES

So far, we've been focusing on the unintentional, bumbling failures of government agencies when it comes to protecting personal privacy. But some government-related privacy problems aren't mistakes. They're the result of intentional policies and practices.

For example: The U.S. Department of Education runs a central database of personal information on tens of millions of people who have taken government-guaranteed student loans. The database, known as the National Student Loan Data System, was created in 1993 to help determine whether students are eligible for student aid and to

assist in collecting loan payments. About 29,000 university financial aid administrators and 7,500 loan company employees have legitimate access.

Thousands more have *unauthorized* access via improperly shared passwords and misused accounts. These shady users download lists they use to bombard borrowers with mailings and phone calls for credit cards, refinancing or consolidation of existing loans and other services.

In one meeting with university financial aid directors, Theresa Shaw—chief operating officer of the Office of Federal Student Aid, which manages the database—admitted that **lenders had been mining it for student data with increasing frequency**. Shaw said her office had first noticed a problem in 2003, when refinancing packages known as "loan consolidation" started becoming popular.

The database was a powerful tool for marketing campaigns. It contained complete information—including **Social Security numbers, e-mail addresses, phone numbers, birth dates and existing loan balances**—on some 60 million borrowers. And the information was not available through standard commercial brokers.

As we've seen before, the issue here is that legitimate users seek details on one person at a time while crooked ones seek **details on many people at once**. The databases **don't distinguish** between the different kinds of downloads. They should.

Department of Education officials grew so concerned that, in April 2005, they sent out a letter to database users warning that inappropriate use of the system—in other words, **looking for information without authorization**—could cause their access to be revoked. The letter said the agency was "specifically troubled" that lenders were giving unauthorized users such as **marketing firms and collection agencies** access the database.

> **The warnings didn't work. By early 2007, the improper use had grown so pervasive that Department of Education officials were considering a temporary shutdown of the database to review access policies and tighten security.**

And there were other problems that hinted at corrupt ties between Department of Education employees, university officials and shady lenders. In April 2007, a Department of Education employee named Matteo Fontana was suspended after media outlets reported that he had owned more than $100,000 worth of stock in a student loan consolidation company called Education Lending Group **while he worked in the office that managed the student loan database**.

As a result of the Fontana case, investigators discovered that financial aid officers with **three major universities** (Columbia, USC and UTexas-Austin) who served on a Department of Education advisory committee overseeing the database also owned shares in Education Lending Group.

NOTES ON THE PRIVACY ACT

Whenever the federal government stumbles through a controversy involving personal information, some aggrieved party is bound to cite the **Privacy Act** as grounds for damages. And this is what the Act was intended to do—make government agencies behave responsibly when handling personal data.

Since the Privacy Act was passed in 1974 (it's been revised and updated several times), its effect has been mixed. Rather than forcing government agencies to behave more carefully, it has **encouraged some agencies to outsource data management** to private-sector contractors. And then act cagey about exactly who is storing precisely what data.

Some of the revisions to the Act limit this "hiding behind" private-sector contractors. According to one often-cited section of the Act, **government contractors have to follow the same rules** that government agencies do. Specifically:

> When an agency provides by a contract for the operation by or on behalf of the agency of a system of records to accomplish an agency function, the agency shall, consistent with its authority, cause the requirements of this section to be applied to such system. ...any such contractor and any employee of such contractor...shall be considered to be an employee of an agency.

However, even when this rule applies, the agency—not the contractor—remains "the only proper party defendant" in a Privacy Act civil lawsuit.

NO-KNOCK POLICE RAIDS

Sometimes, debates over the legal theories about privacy get political or philosophical. Some situations can even seem humorous...in an absurd way. **Others aren't funny at all.**

So-called "no-knock" police raids are an invasion of privacy run amok. Responding (some say *over*responding) to two issues—illegal drug trafficking and terrorism—most states in the U.S. have passed laws in the 1990s and 2000s that give law enforcement agencies greater flexibility in how they go about arresting criminal suspects.

Some states have followed the lead set by the federal government with its USA Patriot Act; namely, they use new laws to alter older laws in ways that make things easier for law enforcement agents.

Specifically, **these laws allow police to enter homes and other premises without announcing themselves**. In some cases, the police need to get a special warrant to do this; in other cases, they can do so with a standard warrant.

Also, many of the groups that use "no-knock" tactics are antidrug **task forces that combine federal, state and local law enforcement officers**. From the government's perspective, these task forces have many tactical advantages over traditional single-jurisdiction law enforcement agencies.

Among these advantages: **A task force can look in various courts for cooperative judges.**

In theory, no-knock raids allow police to arrest more safely suspects who are armed and dangerous. In practice, they cause more trouble than most government agencies like to admit.

One of the reasons no-knock raids are so problematic: Police often use SWAT teams and other paramilitary units to carry out the raids. **Paramilitary tactics are dangerous when combined with any process that generates a lot of false positives.**

Consider the following examples—taken from just one three-month period in 2006:

- On March 22, police in Horn Lake, Mississippi raided a home after receiving a tip that a methamphetamine lab was being operated inside. Around 4:00 a.m., the police force's paramilitary unit arrived at the suspect address—where officers found two houses on the property. They picked the **wrong house** and ended up injuring an elderly couple. Eventually, the police found the meth lab in the other house.

- On March 23, a group of local law enforcement officers conducted a 1:30 a.m. no-knock drug raid on a house in Macon, Georgia. During the raid, a policeman was shot and killed by two residents who thought the house was being attacked by rival gang members. **Once the raiding party announced**

itself as law enforcement, the suspects surrendered immediately.

- Between April 18 and 20, SWAT teams in Buffalo, New York conducted a series of no-knock raids on some 36 homes in a coordinated effort they called "Operation Shock and Awe." They arrested 76 people suspected of various drug crimes. However, most of the arrests were worthless, legally; a month later, only 20 of the 76 suspects still faced charges. Almost half had to be released within 24 hours of arrest for **improper use of the underlying search warrant**; courts later dismissed the charges against two dozen others.

- On the evening of June 15, officers from the "Combined Ozark Multi-Jurisdictional Enforcement Team" conducted a no-knock raid on the Missouri home of Patricia Durr-Pojar and her son, Curtis Pojar. The police had received a tip that Durr-Pojar and her son were running a meth lab inside. The mother and son tried to run from their "attackers" and were roughly subdued. The police found no meth and no meth lab. Later, a local Sheriff told a newspaper that **Durr-Pojar's injuries were her own fault, because she "shouldn't have run" when unidentified intruders broke into her home**.

- On the morning of June 27, members of a multi-jurisdictional task force entered the Caphaw, Alabama home of

Kenneth Jamar. There was some question about whether the agents identified themselves. Inside, they "met with aggression from an armed subject" and "neutralized that threat." In other words, **they shot Jamar**—a man in his 50s suffering from gout. Family members questioned the police account of the raid, noting Jamar's frail health. Worse, **the police had entered the wrong house**. They were actually looking for Jamar's nephew, who was wanted on drug charges and lived nearby. The task force had not included the local sheriff in its plans. If it had, he could have helped locate the right house.

As we've noted, these stories are shocking—and some even seem slightly comical...**as long as you're not the person being beaten or shot**. If you are, the stories aren't funny at all.

The important point to keep in mind is that privacy rights are meant for more than just protecting individuals. They are meant to **rein in government agencies that, left to their own devices, can behave badly**.

The essential tools of privacy—the Fourth and Fifth Amendments to the U.S. Constitution, state laws that explicitly define privacy rights and legal precedents support the right to be left alone—are all **checks on government excesses**. Judging from the track record of no-knock raids, **Americans need these protections**.

CHAPTER

8

NATIONAL
IDENTITY CARDS

Some security professionals insist that a consistent national ID system would make life in the U.S. (or any developed country) safer.

That point is debatable.

> Remember: All of the 9/11 hijackers had some form of ID that was examined and accepted before they boarded the planes that they later crashed.

What's not debatable is that a national identity card system would be a significant erosion of personal privacy. And it very well could be **the foundation for even bigger threats to privacy**.

In this chapter, we'll consider the mechanics of some proposed national ID programs. And we'll consider how those programs can affect everyone's privacy.

In May 2005, George W. Bush signed "The Real ID Act" into law. After some initial doubts, he em-

braced the Act, saying it "facilitates the strength-
ening by the states of the standards for the security
and integrity of driver's licenses."

**The Real ID Act is the closest the United States has
ever come to national ID system, even though such
systems have been discussed for generations.**

The Act advanced farther than any previous national
ID plan because it seemed to do less. Its supporters
liked it as much for its **supposed efficiency** as for
its security potential. Instead of creating a whole
new system, the Real ID Act **coordinated existing
ID card systems** in the various states.

Doing so, it would effectively turn state-issued
driver's licenses into **national identity cards** and a
database connecting all of the card systems into one
resource for identifying any citizen or resident.

The Real ID Act says that state driver's licenses and
state ID cards will not be accepted for "federal pur-
poses"—including boarding an aircraft or entering
a federal facility—unless they meet the law's nu-
merous conditions, which include:

- standardized data elements and secu-
 rity features on the IDs;

- a "machine readable zone" that will al-
 low for the easy capture of all the data
 on the ID by stores or anyone else with
 a reader;

- the construction of a 50-state, interlinked database making all the information in each person's file available to all the other states and to the federal government;

- a requirement that states verify the "issuance, validity and completeness" of every document presented at a motor-vehicle agency as part of an application for a Real ID-qualified card.

So, starting around May 2008, Americans will need **a federally-approved ID card** (a passport will also do) to travel on an airplane, open a bank account, collect Social Security payments or take advantage of nearly any government service.

The cost of implementation—by some estimates as much as $23 billion—will be paid by the states. However, the Feds are linking **highway maintenance monies** that more than make up for that to the implementation of the Act.

There are other challenges. The details of **what "machine-readable" means** have been left to the Department of Homeland Security—which, less than a year to the start date, hasn't issued a definition.

Experts say "machine-readable" could mean a **magnetic strip**, an **enhanced bar code**, **biometric data** or an **RFID chip**.

The first stage of implementation of the Real ID act has been the creation of a national registry of tens of millions of drivers. Accessible to officials across the nation, this database—operational in 2008—is

almost certain to contain an individual's finger-prints, photo, Social Security number, immigration status and more (possibly including other biometric data or RFID chip information).

The federal government has been cagey about what precisely it seeks from the Real ID Act. Department of Homeland Security spokespeople have been careful to state that DHS isn't creating any sort of security registry—its role in Real ID will simply be to analyze data provided by the states.

WHAT THE LAW MEANS FOR YOU

You'll still get your ID card through **your state department of motor vehicles** or the equivalent agency. The card will come with "physical security features designed to prevent tampering, counterfeiting, or duplication of the document for fraudulent purposes." It will likely take the place of a traditional driver's license.

But **the verification process will be more rigorous**. You'll need to bring a "photo identity document," prove your birth date and address and show that your Social Security number is what you claim.

The state DMV will verify that these identity documents are legitimate, digitize them and **store them in a permanent database**—which will be a rich target for hackers and identity thieves.

Supporters say that the Real ID Act follows the ID card recommendations that the 9/11 Commission made in 2005. More ambitiously, Rep. James Sensenbrenner claimed during one congressional debate that the Real ID Act will:

> hamper the ability of terrorist and criminal aliens to move freely throughout our society by requiring that all states require proof of lawful presence in the U.S.

To this end, the DHS has indicated it may **add requirements for biometric features and other tracking tools** as time goes on. The State Department already plans to embed RFID devices in passports; and DHS has discussed issuing RFID-outfitted cards to foreign visitors who enter the country.

Also, the Act may give all sorts of groups an excuse to **demand personal information**. Barry Steinhardt of the American Civil Liberties Union, predicted:

> It's going to result in everyone, from the 7-Eleven store to the bank and airlines, demanding to see the ID card. They're going to scan it in. They're going to have all the data on it from the front of the card.... It's going to be not just a national ID card but **a national database**.

The fact that state IDs have been different has been *good* **for personal privacy**. Stores, banks and airlines can't swipe IDs through readers because some have bar codes, others have magnetic stripes—and others have neither. Once the cards all have the same features, **stores and banks and airlines may start demanding that everyone swipe their IDs**.

SOME STATES WON'T COOPERATE

Not all states support the Real ID Act—or are desperate for the federal highway maintenance money that's the "carrot" tied to compliance. In January 2007, the **Maine** legislature overwhelmingly rejected the federal requirements for national identification cards, marking the first formal state opposition to the Real ID Act.

Maine legislators claimed that, even counting the federal highway money, the Act would have cost the state $185 million over five years and inconvenienced residents—requiring them to **bring identification papers to the motor vehicle agency to be uploaded into the coordinated database**.

Opposition to the Real ID Act in Maine was nonpartisan; the objection was approved by a 34-to-0 vote in the state Senate and by a 137-to-4 vote in the House of Representatives.

In April 2007, Montana Governor Brian Schweitzer signed into law Montana's rejection of the Real ID Act, saying "the best way for Montana to deal with the federal government on this issue and many others is to say 'No. Nope. No way and hell no.'"

> **The Montana law says plainly: "The state of Montana will not participate in the implementation of the Real ID Act of 2005." And it explicitly directs the state motor vehicle department "not to implement the provisions."**

Other states that have either passed laws against the Real ID Act or have considered doing so included Washington, Massachusetts, Idaho, Georgia and Arkansas.

> Some if these states were considering creating "driving privilege only" cards, which would not qualify for federal ID but would still allow a holder to operate a vehicle legally. This might be an appealing option to people concerned about privacy.

But there will be political on resisting states to comply. Real ID Act opponents argue that if even six or eight states refused to participate, the system would be thrown into crisis—since its design assumed that all 50 states will participate.

IMPLEMENTATION AND POLITICS

The Real ID Act and its backlash served as yet another example of **the delicate balance between individual privacy rights and the government's desire** to identify travelers, applicants for federal benefits and anyone else who may pose a threat to its security or economy.

Supporters of Real ID say the technology is essential for government officials in the post-9/11 world to know who's who. Security industry representatives say that the technology itself and policy decisions on how it's implemented will do a fine job of protecting privacy.

> **The thinking is that, because the 9/11 hijackers passed through airport security with state-issued ID cards, the standards that states use to grant the cards must be tightened. But that perspective would transform the nation's ID system to enable an airport security system that needs reform itself.**

The most troubling of those effects is the coordinated network of state databases—that will store scanned images of citizens' personal documents. According to the law, states must keep this proof on file for seven to 10 years; and the data must accessible by all the other states.

The states that have rejected the Real ID Act may be making more than just a principled stand. They may be dodging a logistical bullet. Those that accept the Act are anxious to see detailed specifications from the DHS—because the new licenses are supposed to be issued as of May 11, 2008. That doesn't leave a lot of time for major changes that will be required in some motor vehicle departments.

RFID CHIPS, A PRIVACY PROBLEM

As we've noted, the Real ID Act's demand for "machine readable" technology suggests the use of **Radio Frequency Identification (RFID) chips** or similar technology. In the 2000s, RFID chips have become a popular suggestion for solutions to just about any security risk. The chips are small, durable and can be tracked just about anywhere in the world from just about anywhere in the world.

> RFID chips are great for tracking cargo shipments; but they pose lots of problems as tools for tracking people—or containing personal information.

There's a difference between a magnetic strip that lets a machine read who you are and where you live and **an RFID chip that lets a government agency see where an ID card is** at any given moment.

Also, because RFID chips emit radio signals that can be read at a distance, they could be read by criminals looking to steal or misuse the personal data they contain.

Real ID Act supporters say such fears are overblown. They admit that RFID chips made for tasks like tracking cattle and retail merchandise can transmit their signals long distances and **shouldn't be used in ID card systems**. Rather, ID card reading systems would use "contactless security controllers," which are similar to—but critically different than—"true" RFID systems.

> In fact, the chips that the U.S. State Department is using in its "e-passports" are of this "contactless" sort...and not conventional RFID chips, as has been widely (and mistakenly) reported.

The contactless chips can be programmed to be more secure than conventional RFID chips. There

is little risk of their signals being intercepted, because **the chips would need to be held within three to four inches of a reader to work**.

Still, the debate over the security of RFID and contactless chips continues. In the summer of 2006, Lukas Grunwald—a German data security expert—cloned a chip from an e-passport prototype at security conference in Las Vegas. His feat was dismissed as nothing more than a "media stunt" by the major contactless chip makers.

Grunwald said that his critics missed a key point of his demonstration. Because the ID system accepted data from an untrusted source (the cloned chip), it raised the possibility that:

> with some additional malware, this could infect the inspection system with a Trojan, or attach and shut down the inspection system by making an alert on any passenger and suspecting him as a terrorist.

A spokesman for one of the two main contactless ship manufacturers said the ID system would not activate the chip until the card had passed several security tests. He told one tech media outlet:

> What I object to is the assumption of guilt and the presumption of failure that some of the privacy advocates place on the technology, often because they don't understand how it is going to be implemented.

This back-and-forth over the security of RFID or contactless chip systems misses the point. Even if they work perfectly, **these systems transmit sig-**

nificant amounts of personal information through an unsecure medium—the air. Whether the transmission is a few inches or a few hundred miles, it's not a good prospect for personal privacy.

THE COST OF THE REAL ID ACT

We've mentioned some of the money issues that surround the Real ID Act—the costs passed down to the states and the highway maintenance moneys that the Feds think would act as the "carrot" to incentivize states to absorb those costs.

Still, opponents of the Act insist the cost to states will be much higher than anyone anticipates. They say that retraining DMV employees, using computer chips, verifying documents and linking databases will cost so much that the whole plan will collapse before it's implemented.

Whether the final cost is $9 billion or $25 billion, there's little doubt that the Act will significantly strain state governments.

These costs would ultimately be borne by the residents of each state—if not in the form of higher fees at the DMV, then in the form of higher taxes. That's why some Real ID Act critics call it a **hidden tax increase.** And some state government officials say that it will be simply impossible to comply with the Act by its implementation target of May 2008.

In some cases, individuals would not be able to obtain birth certificates, or the documents they have in hand upon arriving at the DMV would not be able to be verified.

Over 30 million people in the U.S. are foreign-born, and many of them were born in remote undeveloped nations or other places where no birth records are kept, or in places where any records that do exist might be difficult or impossible to obtain.

It's not clear what would happen to such people. **The Real ID Act is silent on how such individuals should be treated**, so DMVs would need to figure out whether they would be denied identity papers or if their applications could be processed in some other way consistent with the Act.

PHILOSOPHICAL ARGUMENTS AGAINST

The Real ID Act will be a key piece of infrastructure for—and dramatically accelerate—a "surveillance society" in the United States. Once in place, **it's likely to be used for the routine tracking, monitoring and regulation of individuals' movements** and activities.

It will likely be exploited by the private sector; and it will likely expose people to greater risk of identity theft and other personal security risks.

> **The distributed database system is a "slippery slope" toward a government repository of complete personal information on every citizen. That's _really_ not good for personal privacy. Supporters are afraid even to mention this aspect of the Act; they seem to sense that it's a troubling proposition.**

A national ID card will erode privacy by helping to consolidate personal data in a manner that clearly moves beyond any individual person's control.

The **security problems with maintaining centralized databases** have been repeatedly demonstrated over the years—most recently in the rash of cases in which personal information held by commercial database companies has fallen into the hands of identity thieves or other crooks. The government's record at information security is no better.

The development of **distributed or centralized Real ID Act databases** will accelerate a larger trend toward a public-private "Security-Industrial Complex." Data aggregators like ChoicePoint, Acxiom, Lexis-Nexis and others already make up an enormous, multi-billion-dollar industry that builds dossiers on individuals using a variety of sources. As we've seen earlier, the government turns to such companies for help with data security functions.

The FBI pays millions of dollars each year to Georgia-based ChoicePoint for data-security advice and services. And ChoicePoint had its databases hacked by a gang of second-rate Nigerian con artists!

The real problem isn't the piece of plastic itself but the larger network of databases, documents and identity papers—in short, what privacy advocates dread as an "internal passport." Whereas the old driver's license was a license to drive, the new documents will be a license to leave your house.

No matter how the Real ID Act is implemented, you can be sure that the big data aggregators will be standing ready to help manage the distributed multi-state database.

And the data aggregators will be **just the first stage** in the commercial use of the Real ID Act. In time, every big-box retailer, convenience store and restaurant will scan customer data and sell it to Choicepoint or the others for a few cents.

This process has already started, even without the Real ID Act. Your grocery store, for example, probably uses some form of "**loyalty card**" to keep detailed records of what you buy. On-line retailers like Amazon keep records of what you read; airline frequent-flyer accounts keep track of where you fly.

> **The fact that all this information remains scattered across many different databases is the best privacy protection that many Americans have. A standard national ID card—and the database behind it—will eliminate that protection.**

A final point: **ID cards do not reveal anything about bad intent.** Stalkers, violent ex-spouses and other bad actors will find ways to use the Real ID databases. After the first few abuses, Congress will feel obligated to pass laws—to address concerns that public records are being used by crooks.

And a whole new cycle will begin....

9

MEDICAL PRIVACY
& HIPAA

The National Committee on Vital and Health Statistics defines the term *health information privacy* as:

> an individual's right to **control the acquisition, uses or disclosures** of his or her identifiable health data.

We think this is a fine definition; it influenced the general definition of *privacy* that we suggested in the first chapter of this book.

Essential to this definition is the **right of consent**—which means that an individual patient must actively consent to his or her medical information being shared among third parties. Without this right, it is impossible to ensure medical privacy.

In August 1996, the U.S. Congress enacted the **Health Insurance Portability and Accountability Act** (HIPAA). The Act was intended to:

1) promote the standardized electronic transmission of administrative and financial health care records traditionally carried out manually on paper; and

2) establish security and privacy standards.

Prior to HIPAA, **state laws** controlled the confidentiality of most health information; so, privacy protections varied from state to state. Under HIPAA, federal regulations supersede state laws.

All states have statutes regarding public safety and mandatory reporting of communicable diseases. However, both federal and state laws protect individual patient privacy. These two goals—management of public health and medical privacy—often clash. They may be impossible to reconcile.

HIPAA's genesis was the desire of Senator Nancy Kassebaum to protect the **portability and continuation of health insurance coverage** for workers who move from job to job. On its way to passage, the bill attracted numerous sections unrelated to portability.

A BAD "PRIVACY RULE"

Of all those add-ons, the most confounding part of HIPAA is its **so-called "Privacy Rule."** The rule does little, in fact, to protect anyone's privacy.

When HIPAA was passed into law, it didn't have a Privacy Rule. Instead, it called on the U.S. Department of Health and Human Services (HHS) to develop guidelines that protect individuals' medical privacy. And it gave HHS four years to do so.

HHS took almost all of that time. It circulated its first draft privacy regulation in November 1999; it issued the final Privacy Rule in December 2000—near the end of Bill Clinton's second term. Then-HHS Secretary Donna Shalala said the Rule would

> improve patients' access and control of their medical information. It will set boundaries on the use and release of medical information. It will establish standards that health care providers and others must meet in protecting the privacy of health information.

In January 2001, the Clinton Administration departed and the incoming Bush Administration extended the comment period on the Privacy Rule. This extended review was expected to take a long time; George W. **Bush had mentioned concerns about the perverse nature of the Rule** in public statements about being a "privacy President."

> **But, during the first months of the Bush Administration, the HIPAA Privacy Rule served as a convenient "Trojan Horse" for last-minute insertions, expansions and changes that had little or nothing to do with medical privacy. The bureaucratic double-talk stayed the same—what changed was the parties benefiting from the misdirection.**

In April 2003, the Bush Administration surprised many observers by announcing summarily that a **new version of the Rule** would be implemented—two days later. The final Privacy Rule included several key departures from earlier draft versions:

1. Although final Rule kept the language about providing Americans a "right to medical privacy," it created a federal mandate that required doctors and other health-care practitioners to **share patient records with the federal government—without patient consent**.

2. Disclosure of patient medical records—again, without consent—could be made for many "broad reasons," including FDA monitoring purposes, "oversight" of the health care system by federal agencies, public health surveillance activities, licensure and disciplinary actions, U.S. cooperation with a foreign government on health issues and more.

3. The draft version had required "covered health care providers and health plans to take action on a request for access [to personal medical information] as soon as possible, but not later than 30 days following the request." The final Rule "permits a covered entity to take a total of **up to 60 days** to act on a request for access to information maintained on-site and up to 90 days to act on a request for access to information maintained off-site."

4. The draft version applied only to health information "that is or has been electronically transmitted or maintained by a covered entity;" it did not apply to "information that was never electronically maintained or transmitted by a

covered entity." The final Rule extended its scope to **all individual health information in any form,** electronic or nonelectronic. This included individual health information in paper records that had never been electronically stored or transmitted.

5. Even more troubling, the Rule states:

 An individual's access to protected health information created or obtained by a covered health care provider in the course of research that includes treatment may be temporarily suspended for as long as the research is in progress.

 So, if your records are being used as part of "research," you may not be able to get them at all. (This policy may reflect a **pharmaceutical industry desire to conceal bad drug trial results.**)

6. The Rule prevents access by patients to learn how their records have been disclosed to others. It authorizes "a health oversight agency or law enforcement official" to instruct an institution to withhold accounting from a patient if such accounting is likely to impede "the agency's activities."

The blurring of **electronic and paper records** was especially troubling to some physicians and patient-advocacy groups. They argued that privacy protections for digital records must take into account differences with paper records, in terms of scale and ease of access.

> Paper records don't pose the privacy risk that elec-
> tronic records do. Millions of paper records can't be
> stolen or lost on a laptop; millions of people who
> work for corporations and government agencies can't
> access a paper record with the click of a mouse.

Some other troubling points in the final version of the Privacy Rule:

- though the Feds insist that patient consent is not coerced, "health care providers and institutions **may refuse to treat** patients if they won't give consent to share their medical records;"

- once an individual's medical records have been **disclosed to a third party**, the Privacy Rule no longer protects that information;

- there is nothing in the rule that prohibits the federal government, state governments or private parties from **compiling databases** of patient information without patient consent;

- the Rule calls for the establishment of a "**unique patient identifier**" numbering system that could end up in various databases—both government and private-sector. This number is supposed to "de-identify" the records of individual patients; but it could be used to do just the opposite—to "re-identify" patients seen by multiple medical services personnel and facilities.

The net effect? The HIPAA Privacy Rule does more to undermine patient privacy than support it. The Rule's restrictions on patients' access to their own records and provisions for wide government access were contrary to common-sense notions of patient privacy.

The key "privacy" principle in HIPAA is not an individual's right to control access to personal medical information; it's the right of thousands of providers and hospital administrators (called "covered entities") to **violate that privacy—without notice, without audit trails, retroactively...and even over a patient's explicit objections**.

LEGAL CHALLENGES FALL SHORT

People in the health care industry had a sense of what was going on during the Clinton and early Bush Administrations.

Some groups tried to stop the changes that the final version of the Privacy Rule made to earlier versions.

In the Fall of 2001, a group calling itself the Association of American Physicians and Surgeons (whose members included Congressman Ron Paul of Texas) filed suit in federal court in Houston, **challenging the constitutionality of the Privacy Rule**.

Judge Sim Lake (who would later gain some fame as the judge overseeing several criminal trials related to the collapse of Enron Corp.) ruled that, because the regulations were not fully in force, the legal issues were not "ripe" for litigation.

> The judge also concluded that the extension of the regulations to paper, as well as electronic records, was proper.

Lake also wrote that patients' fears of disclosure of their records to the government, and a resulting chill on patient-physician communications, were **just hypotheticals that depended on "a succession of increasingly unlikely events."** After all, "the Secretary may decide not to request access to any protected health information."

In April 2003, a few days before the final Privacy Rule was to be enforced, a coalition of patient advocacy groups filed the lawsuit *Citizens for Health v. Michael O. Leavitt* in a Philadelphia federal court. The suit's main goal was to **eliminate the amendments to the original Privacy Rule** adopted under HIPAA and **restore the right of consent** granted in the original Rule versions.

Patient advocacy groups argued that the Amended Rule eliminated the right of law-abiding citizens, who posed no threat to society, **to be let alone**. And they noted that Justice Louis Brandeis had called this right "the most comprehensive of rights and the right most valued by civilized men."

Their arguments didn't hold. The Philadelphia court ruled in favor of the government, concluding that the final Rule *did* eliminate patients' medical privacy—but that there was no constitutional violation because the Rule provided a "consent process."

The patient advocacy groups appealed. In November 2005, a federal appeals court upheld the lower court's decision. However, it did acknowledge that some of the terms, definitions and conditions used by the HIPAA Privacy Rule raised issues that might be litigated at a later date.

But, in October 2006, **the U.S. Supreme Court declined to hear the lawsuit.** That effectively ended the legal challenges to the Privacy Rule.

However, some interesting points did emerge from these lawsuits:

- HHS conceded that **the right to health privacy had been eliminated** in a two-step approach. First, HHS eliminated individuals' right of consent and ability to control the use of their health information. Second, it conferred federal authority on "covered entities" to use and disclose the health information of individuals without notice or consent—and even against express wishes;

- HHS conceded that it had "always" intended to permit disclosure of individuals' health information for routine purposes to occur "with little or no restriction" and that there should be a "free flow" of health information;

- HHS had intentionally eliminated the preamble to the draft Privacy Rule that **protected the right of consent** created by doctor-patient privilege in other federal, state or local laws;

- HHS had **specifically targeted psy- chotherapist-patient privilege** in eliminating consent and establishing "regulatory permission" for the use and disclosure of *all* health information;

- HHS confirmed that it permitted dis- closure of personal health data that had been **created before the enactment of HIPAA**—even if that information had been placed in the medical record with the understanding that it would not be used or disclosed without the patient's consent.

CONSTITUTIONAL ISSUES

Even though the main legal challenges fell short, the HIPAA Privacy Rule does seem to conflict with the Fourth Amendment rights of patients to pri- vacy in their medical records.

The Rule creates constitutional trouble by grant- ing virtually unlimited access by government agen- cies, without a showing of cause or a warrant. In doing so, the Rule seems to clash with the 1975 Supreme Court decision ***Whalen v. Roe***, long con- sidered a precedent decision on medical privacy. In that decision, the Court wrote:

> We are [aware] of the threat to privacy im- plicit in the accumulation of vast amounts of personal information in computerized data banks or other massive government files. The collection of taxes, the distribu- tion of welfare and social security benefits,

the supervision of public health, the direction of our Armed Forces, and the enforcement of the criminal laws all require the orderly preservation of great quantities of information, much of which is personal in character and potentially embarrassing or harmful if disclosed. The right to collect and use such data for public purposes is typically accompanied by a concomitant statutory or regulatory duty to avoid unwarranted disclosures.

The *Whalen* Court ultimately supported as constitutional a medical record keeping system that it described in the following detail:

[Medical records] are returned to the receiving room to be retained in a vault for a five-year period and then destroyed as required by the statute. The receiving room is surrounded by a locked wire fence and protected by an alarm system. The computer tapes containing the prescription data are kept in a locked cabinet. When the tapes are used, the computer is run "off-line," which means that no terminal outside of the computer room can read or record any information. Public disclosure of the identity of patients is expressly prohibited....

The HIPAA Privacy Rule doesn't require such careful security. On the contrary, it authorizes various disclosures to "covered entities." Physicians are practically compelled to assist in invasions of their patients' privacy. Institutions are allowed to disseminate personal medical data. All of this is allowed without any corresponding security assurances.

Particularly troubling is the laundry list of **permitted disclosures** *without* **patient consent**. One of the listed items includes disclosure to any public official involved in "activities necessary for appropriate oversight of [t]he health care system."

Once disclosed to a non-covered entity, there is no protection against repeated disclosures. Like Pontius Pilate, these bureaucrats try to wash their hands of responsibility for their actions.

These same bureaucrats and lawyers anticipated court problems with the Privacy Rule, so they took **preemptive evasive maneuvers**. In one court document, HHS staffers admitted:

> The definition of "protected health information" is set out in this form to emphasize the severability of this provision.... We have structured the definition this way so that, if a court were to disagree with our view of our authority..., the rule would still be operational.

OTHER MEDICAL PRIVACY RULES

While the federal definition of the term "right to privacy" remains mired in theory, penumbras and academic conjecture, many states have ratified **specific rights to privacy** into their constitutions. In those states, the HIPAA Privacy Rule clashes with more stringent state laws.

For example, the Constitution of the State of Florida includes a Declaration of Rights which states:

> Every natural person has the right to be let
> alone and free from government intrusion
> into the person's private life....

The Privacy Rule certainly seems to interfere with these state constitutional requirements.

Some privacy experts and medical ethicists say that HIPAA Privacy Rule is not so important and that the law's biggest problem is the "**HIPAA paranoia**" that has some doctors worried about carrying patient charts down the hallway of a hospital.

Other doctors and health care providers argue that no person's medical history is so important that hackers or ID thieves would care enough to steal it.

But both of these defenses of HIPAA fail to understand the nature of privacy problems.

An invasion of privacy doesn't have to be like stalking—with one determined party doggedly pursuing another. It can be the result of broad disclosures of population-wide data that seem impersonal...until a determined party "re-identifies" a medical history and finds that particular person has a medical condition she didn't want anyone knowing about.

A determined party could be **a drug company interested in "target marketing" its products.**

In September 2004, two California-based consumer advocacy groups filed a lawsuit against supermar-

ket chain Albertsons Inc. for just such marketing efforts. The advocacy groups alleged **violations of patient health privacy under state laws**. (Idaho-based Albertsons operates more than 2,500 stores in 37 states under the names Albertsons, Jewel, Acme, Sav-on Drugs, Osco Drug and others.)

The suit alleged Albertsons, working with a group of 16 pharmaceutical manufacturers, used identifiable information from prescriptions to send mail to or call patients—reminding them to refill their prescriptions or **suggesting alternative medications**.

According to the advocacy groups, Albertsons did not give patient data to the drug companies—but **the drug companies paid for and helped design the solicitations**. Still, the use of medical information, including prescription drug data, for marketing purposes without patient authorization is prohibited under many state privacy laws.

The lawsuit, filed San Diego County, asked that Albertsons be ordered to stop the marketing program and return to customers moneys it had received from pharmaceutical firms under the program. The lawsuit did not seek protection under the federal HIPAA Privacy Rule; the advocacy groups sued under California's more stringent privacy laws. Their suit claimed:

> Consumers provide private and confidential medical information to Albertsons for the purpose of filling their prescription(s).
>
> This information includes personally identifiable information including the pharmacy customer's name, address, telephone num-

ber, the medication prescribed and, by deduction, the underlying medical condition.

...Albertsons promotes access to its customers'/consumers' confidential medical information to pharmaceutical companies anxious to increase the name recognition and sale of their drugs. Albertsons secretly enters into commercial arrangements with pharmaceutical companies willing to pay to participate in the Drug Marketing Program. ...The pharmaceutical companies fully finance the Drug Marketing Program.

Albertsons has carefully prepared and propitiously searched its pharmacy customer prescription database. [Employees] use screening criteria furnished by the sponsoring pharmaceutical company to retrieve individual names, numbers and conditions filling a desired profile making the targeted Albertsons' customer receptive to the marketing and advertising pitch for the particular drug at issue....

The Drug Marketing Program allows Albertsons to get a kickback for secretly trading its control of consumers' confidential medical information for pharmaceutical companies' enjoyment.... The pharmaceutical company pays Albertsons for the Drug Marketing Program and the retrieval of the customer profiling by medication, medical condition or other similar factor. Albertsons initially receives a set amount per customer target with Albertsons' normal contract including an incentive pay-

ment for subsequent and enhanced sales of the drugs being marketed.

...Albertsons never discloses the Drug Marketing Program to its customers and proceeds with the Drug Marketing Program without customer knowledge, authorization, or consent. ...

Albertsons disputed the allegations. Its spokespeople said the company had never has sold patient data; and they pledged that the company would mount a vigorous defense.

FITTING PIECES TOGETHER

The privacy risk posed by institutions or corporations is usually a complex combination of interests and databases. The alleged deal between Albertsons and the drug companies is one example of this; the "de-identifying" numbering system that the HIPAA Privacy Rule describes is another.

> Your personal information in any one database may not be a privacy problem—but, when several agencies or companies get together to compare data, invasions of privacy become more likely.

Determined investigators (and, perhaps, determined criminals) might be able to compare different databases to "re-identify" codes or assigned numbers. One way to do this would be to look for databases that include HIPAA numbering codes...but aren't constrained by HIPAA privacy rules.

What kind of database would fit that description? Any consumer reporting agency or credit bureau might. Big insurance data clearinghouses like the MIB Group might, too.

Massachusetts-based MIB—also known by its former corporate name, **the Medical Information Bureau**—is a specialized credit rating agency serving some 600 member insurance companies in the United States and Canada. It collects health and life-style information on consumers who apply for life or health insurance; and it supplies information to just about every life and health insurance company in North America.

In addition to an individual's credit history, data collected by MIB may include medical conditions, driving records, criminal activity and participation In hazardous activities. So, MIB bridges several different data sources: banks and financial services firms, insurance companies, government agencies and individual interviews.

When a consumer applies for life or health insurance as an individual, he or she is likely to be asked to provide detailed medical information. Sometimes the applicant will be asked to undergo a medical examination or to have his or her blood and urine tested. If the tests discover medical conditions that insurance companies consider significant, **the insurance company will report that information to the MIB.** All of the data collected in MIB databases is collected from the insurance applicant and

with his or her permission. File entries are generally deleted after seven years.

MIB is not subject to HIPAA rules and regulations. Instead, it is considered **a consumer reporting agency subject to the federal Fair Credit Reporting Act (FCRA)**.

If you are denied insurance based on an MIB report, you are entitled to certain rights under the FCRA, including the ability to obtain a free report and the right to have erroneous information corrected.

MIB describes its mission in this way:

> We believe in and support a "fair marketplace" where insurance carriers have access to the same level of information as do insurance applicants. ...we support the idea that different forms of insurance can be priced differently for those companies who are willing to accept more risk and consequently charge higher premiums or where the risk pool is broad enough to support it.

Because MIB is—technically—a credit bureau, you can obtain a copy of any file it has on you for free once a year by calling 1.866.692.6901 or by visiting the company's Web site (www.mib.com/html/request_your_record.html).

But, perhaps more importantly, you want to be aware of how many different entities have information on your medical history in their databases. The number is growing all the time.

PEOPLE SENSE SOMETHING BAD

Americans have a general sense that their medical histories are not secure.

A survey conducted in 2005 by the California HealthCare Foundation measured **Americans' attitudes and concerns about health privacy** in the wake of implementation of HIPAA. Over 67 percent of respondents were "concerned" about the privacy of their personal medical records. More than half said they were concerned that **medical claims information might be used by their employer against them** in some way.

And—most troubling—about one in eight said they had engaged in risky behavior that they believed protected their privacy, such as:

- avoiding their regular doctor;
- asking a doctor to alter a diagnosis; or
- avoiding tests altogether.

An earlier survey, conducted in 2005 Gallup Organization, found that an overwhelming majority of Americans did not want the government or other third parties to have access to their medical records—including genetic information—**without their explicit permission.**

Clearly, people have concerns about their medical information being used as the HIPAA Privacy Rule allows. And they're right to have these concerns. **HIPAA undermines medical privacy**, as the term is defined in any logical manner.

STATEMENT FOR MEDICAL PRIVACY

PLEASE PLACE COPIES IN ALL MEDICAL AND BILLING RECORDS

I assert my right of consent as codified in common law, the laws of this state, and in the traditional ethical principles governing medical privacy embodied in the American Medical Association's Code of Medical Ethics, I do not agree to any disclosures of any part of my medical records or my family's medical records without my specific consent.

(Patient signature)
(Date)

Please indicate below whether you agree or refuse to obtain my express consent before disclosing my or my family's health information.

_____ I agree to disclose your health information only with your express consent.

_____ I do not agree to obtain your express consent before disclosing your health information.

(Provider, privacy officer or administrator)
(Date)

[This letter is a standard reservation of rights, drafted by consumer-advocacy lawyers. However, **it may be useless because** the HIPAA "Privacy Rule" allows providers to share your medical information without notifying you.]

10

SEX, LIES
& PRIVACY

There's probably no subject about which people want privacy more than their sex lives. There's also probably no subject about which people lie and distort the truth more.

Consider the hypocrisy that swirled around the false rape charges a stripper made against members of the Duke University lacrosse team. The significant portion of the Internet that's devoted to pornography. The fascination that TV viewers have for "stings" that expose sex predators. The millions of magazines sold each week that publicize the sex lives of minor entertainment-industry "celebrities."

How do rational people in a free society apply privacy to sex? Is it a blanket or handkerchief?

Is a person's sex life a completely private matter? If a person chooses to offer the details of his or her sex life to the public, should the public pay attention?

In this chapter, we'll look for some answers.

THE EXHIBITIONIST'S BOYFRIEND

In the early 2000s, Jessica Cutler was a recent college graduate who'd moved to Washington, D.C. to work as a Capitol Hill staffer. Eventually, she found a job working for U.S. Senator Michael DeWine. To co-workers, she seemed to be one of many ambitious, attractive young women working on Capitol Hill.

But Cutler had some harder edges. She had a complex sex life—which included juggling half a dozen boyfriends at a time. (She'd later claim that some of these "boyfriends" paid her for sex.) During several weeks in the Spring of 2004, **she wrote about her complex sex life on an Internet Weblog** using the *nom de plume* "the Washingtonienne."

> **Cutler's blog offered enough jaded wit and pornographic detail that it caught the attention of larger media outlets. She became one of the Internet's fast-rising (and short-lived) celebrities. Her stories went from being read by a handful of friends to being linked at hundreds of popular Web sites.**

Cutler grabbed many of the opportunities that presented themselves. She posed for naked pictures that appeared in *Playboy* magazine; a major publishing house paid her to write a sexy novelized version of her experiences. But, as Cutler leaped to fame and some quick money, **she dragged other people's private lives into the public eye**.

One of Cutler's boyfriends was a more-senior co-worker, an attorney on Sen. DeWine's staff named Robert Steinbuch. According to Cutler, Steinbuch was among her traditional boyfriends—he didn't pay cash for her company and was interested in an ongoing relationship. At one point, **she referred to him as the "current favorite"** among the men she was seeing.

When "the Washingtonienne" became famous, Steinbuch realized that: a) his girlfriend was sleeping with several other people; b) she thought some of *his* sexual tastes were "freaky;" and c) his supervisors would soon know the details of his sexual relationship with a junior coworker.

That last point could cause him trouble at work. In the meantime, Cutler was cashing in. So, **Steinbuch sued Cutler for invasion of privacy.**

In his suit, Steinbuch stated:

> Cutler's outrageous actions, setting before anyone in the world with access to the Internet intimate and private facts regarding [Steinbuch], constituted a gross invasion of his privacy, subjecting him to humiliation and anguish beyond that which any reasonable person should be expected to bear in a decent and civilized society.

As we've seen before, **the term "invasion of privacy" is a sort of legal umbrella that covers a number of specific legal claims.** In Steinbuch's case, he claimed the tort of "public disclosure of private facts."

In order to prove his claim, Steinbuch would have to establish a number of facts common to any such invasion of privacy claim:

1. publication must be made of **facts that are, in fact, private**;

2. the injured party has to be identified as part of the publication;

3. the private facts being publicized have to be "highly offensive;"

4. there must be an "absence of legitimate concern to the public" in the publication of the facts.

Because it involved people working in politics and rather graphic sexual details, Steinbuch's case drew more media attention than he may have expected. Legal pundits predicted that he'd have a relatively easy time establishing points 2 through 4.

> **The requirement that the publication "identify" the harmed party is not a literal one. Numerous courts have noted that a name is not "magic." Using details or initials may identify a person clearly enough to satisfy the requirement.**

Cutler had used Steinbuch's initials and other descriptions throughout her blog. In his lawsuit, Steinbuch claimed that he

was clearly identifiable to a substantial segment of the community as one of the sexual

partners of Cutler described in her public blog. **Cutler used [Steinbuch]'s initials, "R.S." and his first name** to refer to him. Cutler also identified [Steinbuch] in her public blog through his religion, Jewish; his job, Committee Counsel to the Senate Committee on the Judiciary; his place of residence; his general appearance; and details of Cutler's intimate relationship with [Steinbuch] that Cutler had previously disclosed to colleagues and co-workers.

Some legal experts noted that **the last bit** of that quote could be a problem for Steinbuch.

It's a standard conclusion in invasion-of-privacy cases that disclosure to a small group of people is not publication—but that, **once a small group knows private facts, the facts are no longer private.** In other words, "water cooler gossip" can undermine an invasion-of-privacy claim, even if the gossip does real damage to people in the office.

In his lawsuit, Steinbuch stated that Cutler has been gossiping about their sexual relationship in their office before she wrote about it on her Web site. And her Web site seemed to support that time-line; she wrote about them talking about her...talking about their affair to co-workers.

Local case law confirmed that disclosure to a small group of people could **nullify the privacy of facts later disclosed** to a larger audience. A relevant

Maryland case had held that, after a gossiping person sent evidence of adultery to an unwitting spouse, the adultery was no longer a "private fact" for legal purposes (and the adulterers couldn't sue the gossip for invasion of privacy).

So, even if you believe that sexual facts are *always* private, it was possible that—in Steinbuch's case—his affair with Cutler was no longer private at the time when her blog readers read about it. Cutler's blog—as quoted (at length) in Steinbuch's lawsuit—made this point plain. She wrote about their relationship: "The rumor has spread to other offices" and "I have such a big mouth."

Still, Steinbuch's other points seemed strong:

> Cutler caused widespread publication of private intimate facts concerning [Steinbuch] in a manner that would be deemed outrageous and highly offensive to an ordinary reasonable person of average sensibilities....
> The private facts revealed include...physical descriptions of his naked body, the physical details of the sexual positions assumed by Cutler and [Steinbuch] during sexual activity, [Steinbuch]'s suggestion that he and Cutler be tested for sexually transmitted diseases....These disclosures were not made for any purposes relating to the dissemination of news or material published in the public interest.

Although, as we review Steinbuch's claims, it does seem curious that he would **file a suit repeating**

the lurid details from his ex-girlfriend's Web site. (And we've omitted the most graphic parts.)

The lawsuit was still being litigated when we went to press. Legal experts in the D.C. area predicted the case would settle before it reached court. There wasn't much to sustain an on-going action; Cutler's fame—and "deep pockets"—had proved fleeting.

SEX & INVASION OF PRIVACY

While *Steinbuch v. Cutler* might be the best-known sex-related invasion-of-privacy suit in the Internet age, there have been others.

- In *Jessup-Morgan v. America Online, Inc.* (1998 U.S. District Court, Eastern District of Michigan), the plaintiff claimed that AOL had violated her right to privacy by identifying her—in response to a subpoena—as the account owner of an AOL account from which sexually suggestive messages had been posted and which included the telephone number of the plaintiff's husband's ex-wife. The court summarily dismissed the case.

- In *Bret Michaels et al. v. Internet Entertainment Group, Inc. et al.* (U.S. District Court, Central District of California), Michaels—a rock and roll singer and ex-boyfriend of television actress

Pamela Anderson—sued Internet Entertainment Group (IEG) to preclude IEG from offering for sale on its Web site a sexually explicit video of Michaels and Anderson that IEG had obtained from a private investigator. The court found that the content of **the tape was not newsworthy** and could not be considered "public" solely on the basis of Anderson's relatively limited celebrity.

The conclusion a reasonable person can draw from these cases: Invasion of privacy lawsuits are more difficult to win than most people realize.

PUNISHMENT OF SEX OFFENDERS

Law enforcement agencies and courts often struggle with **the best ways to handle predators and other sex criminals**. U.S. courts have tried sterilization, "chemical castration" and various psychological treatments—as well as conventional jail sentences—to deter sex criminals. The treatments that are effective are often unconstitutional and the treatments that are legal often aren't effective.

In June 2006, a federal appeals court in California prohibited a test measuring **a man's response to erotic images was "Orwellian"** because it examined his mind, not his body.

In 2001, Matthew Weber had been released from prison on the condition that he would subject himself to tests in which **a pressure-sensitive electronic device was placed around his penis** and his response to stimulating images was monitored.

> Weber had pleaded guilty to possessing child por-
> nography on his computer and been sentenced to 27
> months in prison and three years of supervised re-
> lease. But he objected to the penile plethysmograph
> test, which had been used (especially in Europe) as
> part of sex-offender treatment programs.

The device had been developed by Czech psychia-
trist Kurt Freund to study sexual deviance; but it
was eventually used by the Czech government—
during its communist era—to identify and "cure"
homosexuals.

In more recent times, the test has been used as part
of treatment programs for sex offenders. But critics,
including the American Psychiatric Association,
have called the test **unreliable**.

Weber appealed the trial court order, arguing that
the test was such an invasion of privacy that it
amounted to **an unconstitutional violation of his
liberty**. He also argued that the test should be re-
served for people who had molested children or tried
to do so. The government countered that actual
assault isn't a requirement for the test (or any simi-
lar term of probation). These things are strictly up
to the trial judge.

The U.S. 9th Circuit Court of Appeals agreed with
Weber, concluding that forcing him to take the test
was an unconstitutional violation of his privacy. The
appeals **court ruling didn't outlaw the penile pl-
ethysmograph test**, but one of the judge's concur-

ring opinions suggested it might ban the test eventually. Judge John Noonan called the test "Orwellian" because it not only measured Weber's genitalia but also his "innermost thoughts." Specifically, the Judge wrote:

> A prisoner should not be compelled to stimulate himself sexually in order for the government to get a sense of his current proclivities. There is a line at which the government must stop. Penile plethysmography testing crosses it.

Even though Weber's crimes were offensive, Noonan's conclusion seems like **a necessary protection of privacy**—not just for the criminal, but for all citizens.

CHILD PORNOGRAPHY RINGS

Like most constitutional protections, **privacy becomes especially important when alleged crimes or wrongdoings are strongly offensive.** In terms of sexual activities, the acts most offensive to most people involve children.

The Internet is full of pornography. And it allows small groups of people with like interests—including *sexual* interests—to gather and share words or images.

The nature of the Internet may create the impression that these gatherings are "private;" but, as we've seen before, Internet chat rooms and **Web sites are neither private nor anonymous.** ISPs keep user logs. And law enforcement agencies can

be aggressive about tracing users, especially when they are suspects in high-priority crimes like child pornography or abuse.

In November 2006, the U.S. Justice Department announced a criminal indictment of Jeff Pierson, a professional photographer from Alabama who operated an Internet-based business called Beautiful Super Models.

Pierson charged aspiring models to take their portraits and post the pictures in Internet "portfolios." He would also **feature some of these aspiring models—especially** those under 18—on the Beautiful Super Models Web site.

The federal prosecutors acknowledged there was no evidence that Pierson had ever taken naked or sexually-explicit pictures of minors. Their charges against Pierson were based on the theory that his models struck illegally provocative poses. "The images charged are not legitimate child modeling, but rather lascivious poses one would expect to see in an adult magazine," Alice Martin, U.S. attorney for the northern district of Alabama, said. Martin's office went on to explain:

> An investigation...revealed that photos featuring a lascivious (clothed) exhibition of genitals or pubic area of young girls were taken by Pierson.... Some of the props and clothing outfits worn by the young girls had logos or messages which showed the girls as sex objects. Pierson was a major supplier of images of child models and grossed about $270,000 from his photos....

Among the suspicious aspects of Pierson's operation was the release that he required parents of his underage models to sign. The release actually **gave him legal custody of the child** during the photography session—an unusual condition.

Pierson's child pornography indictment arose out of a broader FBI and U.S. Postal Inspection Service investigation of child modeling sites, which had been the subject of congressional hearings and media reports.

At the same time Pierson was being charged, the U.S. attorney also announced indictments against Marc Greenberg and Jeffrey Libman, partners in a Florida-based business that ran a Web site called ChildSuperModels.com. It was one of the larger sites that featured photographs of child models (allegedly from Pierson) and had been the subject of local media reports suggesting that it was **an online meeting place for pedophiles**.

> **In March 2007, Pierson pleaded guilty to two counts of conspiracy and mailing, transporting or shipping child pornography. He remained free on bond and was cooperating with the Feds in their cases against Greenberg and Libman.**

Pierson's case wasn't the first of its kind. In 2002, Colorado prosecutors charged James Grady with more than 719 felony charges—ranging from sexual exploitation of children to contributing to the delinquency of minors—for operating a Web site called

TrueTeenBabes.com. The site billed itself as "America's premier teen glamour publication" and sold subscriptions for access to nonnude shots of models between 13 and 17 years old.

TrueTeenBabes.com drew the attention of local television reporters, whose reporting sparked a police investigation. But a jury acquitted Grady, and he subsequently filed a lawsuit asking for $10 million in damages for wrongful arrest. TrueTeenBabes.com was back online after his acquittal.

SO, WHAT'S LEGAL?

In the 1986 decision *U.S. v. Dost*, a federal judge suggested a six-step method to evaluate the legality of images. The six steps include asking:

1. whether the focal point of the visual depiction is on the child's genitalia or pubic area;

2. whether the setting of the visual depiction is sexually suggestive;

3. whether the child is depicted in an unnatural pose, or in inappropriate attire, considering the age of the child;

4. whether the child is fully or partially clothed, or nude;

5. whether the visual depiction suggests sexual coyness or a willingness to engage in sexual activity; and

6. whether the visual depiction is intended or designed to elicit a sexual response in the viewer.

In 2002, Rep. Mark Foley announced a bill called the Child Modeling Exploitation Prevention Act that would effectively ban the sale of photographs of minors. But, under **opposition from civil libertarians** and commercial stock photo houses like Corbis, Foley's bill never gained much traction.

> **Foley, of course, is the same congressman who resigned from office in 2006 after a series of inappropriate, sexual conversations that he'd had with a teenage congresssional page were made public.**

Public outrage over sexual predators leaves judges and juries with the difficult task of making distinctions between lawful and unlawful camera angles and facial expressions—an exercise that has **proven difficult to do** without running afoul of the First Amendment or Constitutional privacy rights.

Some laws try to clarify these conflicts. The most relevant is the federal **Children's Online Privacy Protection Act** of 1998 (COPPA).

However, COPPA doesn't help much with definitions of lawful or unlawful camera angles. It focuses, instead on people who run Web sites...and how they run the sites. Specifically, the law states:

> Whoever knowingly uses a misleading domain name on the Internet with the intent to deceive a person into viewing material constituting obscenity shall be fined under this title or imprisoned..., or both.

...Whoever knowingly uses a misleading domain name on the Internet with the intent to deceive a minor into viewing material that is harmful to minors on the Internet shall be fined under this title or imprisoned not more than 4 years, or both.

...For the purposes of this section, the term "material that is harmful to minors" means any communication, consisting of nudity, sex, or excretion, that, taken as a whole and with reference to its context—

(1) predominantly appeals to a prurient interest of minors;

(2) is patently offensive to prevailing standards in the adult community as a whole with respect to what is suitable material for minors; and

(3) lacks serious literary, artistic, political, or scientific value for minors.

AGAIN, PRIVACY V. ANONYMITY

In this chapter, we have focused on the connections between sex and the Internet. This is partly because the most relevant, recent legal decisions involve both. But there's another reason to compare the Internet and sex: People tend to assume that both can be experienced anonymously—without any connection to people's "daily" lives. But the truth is that neither can.

It may be tempting to think that you can surf Internet Web sites anonymously. But **your ISP's**

servers track and record every move you make—and the government can request those records easily.

It may be tempting to think that you can have an affair with someone "on the down-low" and keep it from your family, co-workers or others. But most sexual relations in the real world **involve other people**—who may want to discuss or discover a private affair and make the matter public.

> A rational person can surf the Internet without hesitation; and a rational person may choose to have an ill-advised sexual affair. But a rational person should not assume that either act is "private" in any reliable sense.

11

THE PATRIOT ACT

When Congress enacted the USA Patriot Act, it dramatically **expanded the government's search and surveillance powers** and eliminated many of tools that courts had previously had to ensure that those powers were not abused.

> According to a March 2007 report from Department of Justice Inspector General Glenn Fine, the FBI had improperly—and, in some cases, illegally—used the Patriot Act to obtain personal information about people in the United States. And, for three years, the FBI had underreported to Congress how often it forced businesses to turn over the customer data.

According to Fine, FBI agents sometimes demanded the data without proper authorization; other times, they **improperly obtained telephone records in non-emergency circumstances**. The report concluded: "we believe the improper or illegal uses we found involve serious misuses of national security letter authorities."

The Patriot Act allows use of so-called "**national security letters**" instead of traditional subpoenas for searches in suspected terrorism and espionage cases. The letters require telephone companies, Internet service providers, banks, credit bureaus and other businesses to produce personal records about customers or subscribers **without a judge's review**.

"In many cases, there was no pending investigation associated with the request at the time the exigent letters were sent," the Fine report stated.

U.S. Senator Russell Feingold (D-WI) issued the following statement in response to the Fine report:

> This report proves that "trust us" doesn't cut it when it comes to the government's power to obtain Americans' sensitive business records without a court order and without any suspicion that they are tied to terrorism or espionage.

WARRANTLESS WIRETAPS

In 2002, President George W. Bush secretly issued an executive order authorizing the **National Security Agency** to conduct warrantless surveillance of international telephone and Internet communications on American soil.

Bush's order referred to the NSA plan as the **Terrorist Surveillance Program** (TSP). Under the program, the NSA could monitor—without obtaining warrants of any kind—telephone calls and e-mails between the United States and overseas if the

government believed that one of the parties was linked to al-Qaeda or other terrorist groups.

In 2005, Bush—responding to media reports—acknowledged the existence of the TSP. The American Civil Liberties Union quickly filed suit against the NSA, alleging that the program was illegal. Federal judge Anna Diggs Taylor agreed with the ACLU's arguments.

According to Taylor:

> It was never the intent of the Framers to give the President such unfettered control, particularly where his actions blatantly disregard the parameters clearly enumerated in the Bill of Rights.

Taylor's ruling was part of a preliminary hearing. The *ACLU v. NSA* case was likely to take a lot of time working its way through the court system. So, **Taylor ordered the NSA to stop the TSP** while the *ACLU* case proceeded.

In January 2007, Attorney General Alberto Gonzales admitted that NSA wiretapping actions were indeed subject to FISA court approval. And he said that **the court had given the NSA the authorization** to proceed with its wiretapping.

The FISA court is made up of 11 regular federal judges, sitting on special assignment. It administers the Foreign Intelligence Surveillance Act—the law governing clandestine spying in the United States.

In a two-page letter to the U.S. Senate's Judiciary committee, Gonzales did not specify what prompted the policy change. But it appeared to be a concession to critics of the NSA program, who had charged that it was unconstitutional for the government to **spy on Americans without any judicial oversight**.

Gonzales's letter did *not* reveal, even in general terms, how the FISA court would oversee the electronic surveillance requests. One possibility was that the FISA court had already **approved the entire surveillance program with a blanket order for future use**—and would not require the Justice Department to provide case-by-case information.

> **However, such a blanket order would amount to a "general warrant" of the sort used by the British against American colonists during the 18th Century. This is explicitly banned in the U.S. Constitution.**

Another question was whether Gonzales's letter—which talked about only the **TSP**—also covered other wiretapping or Internet monitoring programs that were even more highly classified. Gonzales didn't answer *that* question.

Privacy advocates hoped that the FISA court itself would shed light on the matter. Several senators asked presiding FISA court judge Colleen Kollar-Kotelly for copies of the recent authorization.

Whether that information would be released to Congress—much less to the public—remained un-

certain. In a letter dated January 17, 2007, Kollar-Kotelly wrote that she had no objection to furnishing the documents to Congress but that, because classified information was involved, she would have to refer the request to the Justice Department.

At the same time, Justice Department lawyers were arguing that **the ACLU's lawsuit against the NSA should be thrown out** because the government was—after Gonzales's announcement—conducting the wiretaps under FISA authority.

> **In a filing with the U.S. Court of Appeals for the 6th Circuit, Justice Department lawyers said the suit was moot and had no "live significance." They wanted Taylor's ruling vacated and the suit dismissed.**

Most of the details of the new spying arrangement were considered classified by the Bush administration, **including the recent FISA authorization.** As a result, the precise outlines of and legal justifications for the monitoring remained unclear.

> **Also, Bush still claimed the "inherent authority" to engage in warrantless surveillance at any time. Only an order from the FISA court saying that he could not do so would prevent that from happening.**

Even politicians from Bush's own party questioned his position on the warrantless wiretaps. Arlen Spec-

ter, the senior Republican on the Senate Judiciary Committee, sent a letter to Attorney General Gonzales **expressing concerns about the Administration's actions**. Specter wrote:

> the Department of Justice may have a conflict of interest in limiting access to key evidence on national security grounds as a means of controlling the outcome of these cases and obstructing the federal courts....

PATRIOT ACT BEHIND PROBLEMS

The Patriot Act was at the core of the problems between the Administration and the senators. Since its passage in the days after the 9/11 attacks, the Act had been Bush's **justification for a series of invasions of Americans' privacy**.

The most direct example of these invasions: The National Security Letters that the FBI issued, **demanding personal records from businesses** and prohibiting the businesses from telling anyone about the letters.

The original FISA had been drafted to prevent just such actions. In 1975, a congressional investigation revealed that the NSA had been intercepting—without warrants—communications on behalf of the CIA and other agencies for years. The practice outraged Congress and led it to draft a law that would protect Americans from such eavesdropping.

Enacted in 1978, FISA set procedures that the Feds had to follow to conduct electronic surveillance of people believed to be **engaged in espionage or international terrorism against the United States**. The law included various legal safeguards that limited surveillance of people in the U.S. The Patriot Act undid a number of those safeguards.

But that wasn't enough. In April 2007, National Intelligence Director Mike McConnell drafted bill that would **further expand the government's surveillance prerogatives under FISA**.

The changes McConnell sought mostly affected warrants used to investigate suspected spies, terrorists and other national security threats. His suggestions would allow **planting listening devices and hidden cameras, searching luggage and breaking into homes** to make copies of computer hard drives.

> McConnell, who had taken over the 16 U.S. spy agencies just a few months earlier (about the time of Gonzales's announcement about TSP wiretaps), was signaling a more aggressive posture for his office.

According to officials familiar with the draft changes to FISA, McConnell wanted to:

- give the NSA the power to monitor foreigners without seeking FISA court approval—even if the surveillance was conducted by tapping phones and e-mail accounts in the United States;

- simplify standards the FBI and NSA use to get court orders for basic information about calls and e-mails;

- triple the life span of a FISA "warrant" covering a non-U.S. citizen from 120 days to one year, allowing the government to monitor longer without checking in with a judge;

- give telecommunications companies immunity from civil liability for their cooperation with programs like TSP;

- extend from 72 hours to one week the amount of time the government could conduct surveillance without a court order in emergencies.

The proposed changes to domestic surveillance would be so broad that "you have basically done away with the protections of the FISA," said Kate Martin, head of the Center for National Security Studies. It was a process that had been in development for several years.

FOIA AND PRIVACY GROUPS

In an April 2005 complaint, a privacy advocacy group asked a federal court to force the FBI to disclose data about its use of "**expanded investigative authority**" **granted by the Patriot Act**.

The agency agreed to process an Electronic Privacy Information Center (EPIC) **Freedom of Information Act** (FOIA) request for the data quickly—but missed the deadline for even a standard request.

The FBI released a small number of documents in October 2005, after Congress had concluded its hearings on surveillance practices. These documents included reports of intelligence misconduct at various levels within the FBI.

The following month, a federal judge ordered the FBI to release or account for 1,500 of pages responsive to the FOIA request every 15 days.

In an earlier case, EPIC—which makes a practice of filing FOIA requests with secretive government agencies—joined the ACLU and library and booksellers' groups in suing for information concerning implementation of the Patriot Act. That lawsuit covered some information the Justice Department had withheld from congressional investigators.

In November 2002, federal judge Ellen Huvelle ordered the Justice Department to complete its processing of the EPIC/ACLU information request by January 2003.

The Feds released some responsive material but withheld a substantial amount, invoking national security concerns.

In January 2006, in yet a *different* FOIA case, EPIC obtained the first documents released by the NSA on the TSP. These internal messages from the agency's director to staff defended the NSA's warrantless eavesdropping and discouraged employees from discussing the issue with the news media.

In May 2006, more documents obtained by EPIC revealed that a former top official in the Justice Department had doubted that the TSP was allowed under the so-called "Authorization for Use of Military Force Resolution."

In an e-mail, David S. Kris had written that the Justice Department's defense of the program, "had a slightly after-the-fact quality or feeling...."

Several months earlier—in response to *yet another* FOIA request filed by EPIC—a federal judge had ordered the Department of Justice to release documents related to the warrantless wiretap program.

This was the **first court opinion addressing the TSP.** Federal judge Henry H. Kennedy wrote:

> President Bush has invited meaningful debate about the warrantless surveillance program. That can only occur if DOJ processes [EPIC's] FOIA requests in a timely fashion and releases the information sought.

The day before it was required to disclose the documents, the Justice Department asked Kennedy for **an additional four months** to process some of the material responsive to EPIC's request. Kennedy allowed the extra time.

Once the Justice Department completed its processing of the material, any decision to withhold the requested documents would be subject to judicial review—and the judge would be able to order

"in camera" production of the material to make an independent decision about public disclosure.

USING FOIA AS A PRIVACY TOOL

Clearly, the strategy of privacy advocate groups like EPIC was to use **multiple Freedom of Information Act filings** to accomplish two things:

1) occupy government lawyers in the rather hypocritical task of **defending the privacy of the government's efforts to erode** *citizens'* **privacy**; and

2) demand enough information through FOIA filings that **some useful details** might emerge.

> The legal strategy that groups like EPIC follow is to make the FOIA request for information related to a particular "secret" government activity and then sue if the government doesn't respond to the FOIA request. While the second step—the lawsuit—requires an investment of time and money, the first step—the FOIA request—is something that most lay people can do themselves.

If you think someone's personally identifying information has been used improperly by the Feds, you can make a FOIA request for information about that use. If the agency doesn't respond to the request, you can take your filing information to a privacy advocate like **EFF, EPIC or your local ACLU branch** and ask for help with a legal remedy.

FOIA applies to all 15 departments (Justice, Homeland Security, etc.) and 73 agencies in the executive branch of the federal government. It does not apply to the President, Congress or the courts. It also doesn't apply to state governments—although each state has its own freedom-of-information laws.

FOIA grants people the right to request copies of records **not normally prepared for public distribution** and sets standards for determining which records must be made available. **Anyone can request information under FOIA.**

There is no single office that processes or coordinates FOIA requests, so the requester must go directly to the appropriate agency. However, the Department of Justice does act as a centralized source for information about FOIA and for locating all federal government departments and agencies.

The **Privacy Act of 1974** also regulates federal records, restricting the disclosure of personal information that might violate privacy while allowing individuals access to records about themselves.

Because the two acts overlap in some places, information may be released under one while being exempt from disclosure under the other. When seeking information about himself, an individual should file a request **citing both acts** in order to get the fullest possible disclosure; someone seeking information that is not exclusively about himself should cite **FOIA only.**

Each federal agency has its own FOIA Web site that includes advice for filing requests with that agency. The Department of Justice keeps updated links to all other federal agencies' FOIA Web sites at http://www.usdoj.gov/oip/other_age.htm.

The DOJ also keeps an updated list of principal FOIA contacts at all federal agencies, whom you can write, phone or e-mail to verify jurisdiction over data at (http://www.usdoj.gov/oip/foiacontacts.htm).

Before you send your request, you should locate two separate offices within the agency—its FOIA office and the specific office that keeps the particular records you want. Send your request to the agency's FOIA office and identify the office you think holds the records. If it's unclear which agency has the information, it may be a good idea to file a request with more than one applicable agency.

There are several **standard exemptions** that allow government agencies to refuse FOIA requests. For example, the Department of Homeland Security's 2003 FOIA report pointed out:

> The most common reasons reported by DHS components for not granting requests were: 1) the records were exempt from release under **FOIA Exemption 6 (personal records whose release would be a clearly unwarranted invasion of personal privacy)**; 2) the records were exempt from release under FOIA **Exemption 7C (records**

compiled for law enforcement purposes whose release could reasonably be expected to invade personal privacy)....

HOW TO FILE A FOIA REQUEST

The procedure for filing a request for information is straightforward and involves **writing a letter to the appropriate agency** including the most precise detail possible about the information you seek.

The Department of Transportation offers these guidelines:

Your request must be in writing and include the following information:

Provide your name, address and telephone number. Also, if you have an e-mail address, please provide it, so that we can contact you if we have questions about your request.

Specify whether you are making an FOIA or PA request.

Provide as much detail as possible about the records you seek. Indicate whether you are requesting the information in a form or format other than paper.

State your willingness to pay any fees, and how much you are willing to pay as advance authorization.

If you are mailing the request, please mark prominently on the envelope "FOIA Request."

The Committee on Government Reform's *Citizen's Guide on Using the Freedom of Information Act and the Privacy Act of 1974 to Request Government Records* includes this sample FOIA request letter:

(Agency Head
or Freedom of Information Act Officer)
(Name of Agency)
(Address of Agency)
(City, State, Zip Code)

Re: Freedom of Information Act Request

Dear _____ :

This is a request under the Freedom of Information Act. I request that a copy of the following documents [or documents containing the following information] be provided to me: [identify the documents or information as specifically as possible].

In order to help to determine my status for purposes of determining the applicability of any fees, you should know that I am [insert a suitable description of the requester and the purpose of the request. Examples: a representative of the news media affiliated with (the media outlet), and this request is made as part of news gathering; an individual seeking information for personal use and not for a commercial use.]

[Optional] I am willing to pay fees for this request up to a maximum of $_____. If you estimate that the fees will exceed this limit, please inform me first.

[Optional] I request a waiver of all fees for this request. Disclosure of the requested information to me is in the public interest because it is likely to contribute significantly to public understanding of the operations or activities of the government and is not primarily in my commercial interest. [**Include specific details**, including how the requested information will be disseminated by the requester for public benefit.]

Thank you for your consideration of this request.

Sincerely,

(Your Name)
(Your Address)
(Your City, State, Zip Code)
(Your Telephone number [Optional])

The Reporters Committee for Freedom of the Press has **a FOIA letter generator** on its Web site (**http://www.rcfp.org/foi_letter/generate.php**). It asks you for relevant information about your request and drafts the letter for you, then allows you to edit it before saving or printing. **You must e-mail or mail it yourself.**

Many privacy groups keep track of FOIA requests and which government agencies respond best to most. One such group—OpenTheGovernment.org —compiles a "List of the Ten Most Wanted Documents." **The Patriot Act is a factor in most of the top requests.**

BANKING &
PRIVACY

For many people, **the most important privacy is financial privacy**. They want to keep their money transactions confidential—and away from the attention of neighbors, friends, family members...and maybe government tax authorities.

Some consumers believe that the consolidation among U.S. banks that began in the 1980s and continued on through the 2000s has improved financial privacy. But, as we've noted elsewhere, those people make the mistake of confusing *anonymity* (which big banks do offer) with *privacy* (which they do not offer, generally).

> There is no easy system for creating financial privacy in a digital world. Government tax authorities can be aggressive about finding money; and banks—large or small—often hand over customer data to government agents with very little prompting.

Keeping your finances private from neighbors, friends and family may have as much to do with

life-style choices—not spending conspicuously (though you can afford to) and **paying cash** when possible—as it does with any financial planning.

Beyond life-style choices, the classic solution to financial privacy is opening an account (or group of accounts) with a foreign bank located in any of the several countries known as "**privacy jurisdictions**." The best-known of these is Switzerland.

> **Opening a Swiss bank account is not easy. To start, you usually need at least a million dollars in cash and the ability to travel to Switzerland at least once to set up the account. Most people don't have enough money or time to do this.**

Making things ever harder: International banking rules enacted after the terrorist attacks of the early 2000s have added bureaucracy and background checks that limit the privacy of banking—even in "privacy jurisdictions."

Some crooks take advantage of these situations. In May 2007, a man who operated a so-called "warehouse bank" out of his home in the suburbs south of Seattle was indicted for **taking at least $28 million from people who wanted the discretion of a Swiss bank** without going to Switzerland.

The fact that his low-end operation was able to attract so much money shows how badly some people want financial privacy. **And how dumb some of those people are about getting privacy.**

Robert Arant denied any criminal wrongdoing and insisted his only error was failing to file some IRS forms on time.

At his peak, Arant had hundreds of customers for his homemade version of a Swiss bank. Most of these people moved money into Olympic Business Systems (OBS) to **hide assets from ex-spouses or tax authorities**. Most of Arant's customers deposited money in increments of between $5,000 and $10,000; some had six-figure account balances.

Arant advertised OBS's services as essential to people "who would rather not deal directly with the banking system." He promised to keep his customers' identities private while OBS acted as a front for depositing their money in legitimate banks and other financial institutions. Then, he could pay bills or make other transactions on behalf of his clients from those legitimate accounts.

> **OBS charged each depositor about $75 a year in fees for its services, plus additional fees for transactions like wire transfers and options like debit cards.**

Arant had been attracting the Feds' attention for months. The Internal Revenue Service had filed a series of other civil complaints against him, claiming that Arant promoted **abusive tax shelters** and unlawfully interfered with internal revenue laws. Finally, a few weeks before the charges were filed, the Feds brought search warrants to Arant's home and seized computers and paper records.

According to the IRS, OBS was an amateurish attempt to create the kind of financial privacy usually associated with "**offshore banks**" and other asset protection schemes.

What exactly is an "offshore bank"? And does it really achieve the kind of financial privacy that the popular media suggests?

An offshore bank usually isn't a traditional bank, with branches and tellers. In most cases, offshore banks operate under **special licenses** that allow them to conduct banking activities—but not with local residents.

> If "offshore banking" means anything, it means a greater level of confidentiality between the bank and the bank's client than the banks in the client's home country can offer. Offshore banks actively protect the identity of their clients.

So, what people commonly call "offshore banking" is really **a combination of financial services** that help obscure how much money a person has. These services often include:

- finding a foreign country whose banking laws do no recognize court orders and/or decision from the United States;

- forming a corporation or trust in that country that becomes the legal owner of assets like cash and valuables;

- opening a bank account owned by the corporation or trust.

In some countries, the structure of a trust owning the shares of a corporation makes it practically **impossible for any outsider to discover the true ownership of assets**. And, even if the legal ownership can be discovered, most privacy jurisdictions will not disclose the names of corporation owners— unless a government can show that the corporation has been involved in terrorism or criminal activity.

Another important point: Some "privacy jurisdictions" pass laws that specifically state the country **will not recognize civil court judgments** and orders from other countries. (Criminal verdicts are another matter; post-9/11, those are hard to escape.)

So, what are the most popular "privacy jurisdictions" for setting up an offshore bank account? Some of the biggest include:

- Bermuda

- British Virgin Islands

- Cayman Islands

- Panama

- Switzerland

PRIVATE BANKING POST-9/11

In recent years—especially since 9/11—some former offshore banking centers have **compromised their secrecy and privacy laws** to make the jurisdiction no longer a valid offshore jurisdiction.

For example: The Cook Islands (once a favorite off-shore banking center) allows for "mutual legal assistance" with government agents from any country if

a) the government agents make a written request, and

b) the request is for financial information related to the investigation of a crime or offense that, if committed in the Cook Islands, would result in a jail sentence of 12 months or a fine of $5,000.

It doesn't take much to result in a $5,000 fine in most American courts.

Most countries have Mutual Legal Defense Treaties (MLATs) that call for the release of private financial information under certain circumstances. Many off-shore banking domiciles have some form of MLATs.

Generally, MLATs require that a crime being investigated by a government agency from Country A must also be a crime in Country B (the offshore banking domicile from which that information is being requested).

For example: Switzerland has modified its laws to suit EU anti-money laundering standards. Many Caribbean island offshore banking jurisdictions have given in to EU and American pressure; afraid of losing their cruise ship business, they've changed their bank secrecy laws to favor other governments.

NUMBERED BANK ACCOUNTS

The "numbered account" from a Swiss bank is a staple of popular spy movies and novels. These numbered accounts are supposed to provide the **ultimate financial privacy**—with even the bank not sure who controls the money going in and out.

Through the early 1990s, some European banks did offer numbered accounts; but the truth was never quite as colorful as movies make it.

Even James Bond (or his enemies at SPECTRE) would have to show up, in person, at a bank branch and provide valid identification to open a numbered account. So, **the bank (at least its headquarters) always knew who controlled an account**.

What numbered accounts did provide was **anonymity from the people or companies with whom you were doing business**. In that sense, if you were doing business with dangerous or unsavory people, the numbered account might help you hide your identity from them.

But numbered accounts had been dying for years. **European banks started limiting their use** in the late 1980s and early 1990s because so many drug dealers were using the accounts to launder money.

The anti-money-laundering laws that the U.S. and most European countries passed after the 9/11 attacks effectively ended that practice.

> A useful point: Transferring money in or out of a numbered account may be difficult. Many countries prohibit or restrict wires and other "immediate" transactions with numbered accounts.

If you move money into an offshore bank, you will probably be safe from standard bill collectors and legal actions. But **no haven is completely safe**.

The booming global economy has resulted in a growing number of **"asset recovery" law firms** that specialize in international banking rules...and finding money, even in privacy domiciles.

However, these specialty firms are expensive; their fees often start at six figures and move quickly into the million-dollar range. They generally work on extremely large recoveries—**transactions involving tens or hundreds of millions of dollars**—in the aftermath criminal convictions. If the money in question is under a million dollars, these specialty firms usually won't take the case.

There are other tools that you can use to keep money transactions private. **Internet payment services** like E-Gold—which has gotten into legal trouble for its alleged connections to money launderers— offer significant anonymity. E-Gold operates in a privacy jurisdiction and doesn't collect any ID on users; in fact, it doesn't know who its users are.

E-Gold does require every user to have **an e-mail account**. But that's an easy thing to establish pri-

vately. For example, e-mail services like Hushmail (www.hushmail.com) offer free accounts. And these services don't pass on users' IP addresses in their e-mail headers.

So, the privacy-minded person can use E-Gold and anonymous e-mail to create an untraceable online commerce account. Here's how:

1. Create an "open" E-Gold account using your real bank account and a standard e-mail address.

2. Send a wire and pay openly for gold through an E-Gold merchant—who places the gold in your open account (there will be traceable links among you, the gold merchant and your open E-Gold account).

3. Create a "gray" E-Gold account using a private e-mail address.

4. Transfer funds from your "open" E-Gold account to the "gray" account (there will be a traceable link between your open account and the gray account—but no easy details on the gray account).

5. Create a "private" E-Gold account using a private e-mail address.

6. Transfer funds from your "gray" E-Gold account to the "private" account (there will be no traceable links on this transaction).

Doing business with the private E-Gold account may create traceable links between that account and

others...but none of those transactions or links will be traceable back to you.

GRAMM-LEACH-BLILEY ACT

The 9/11 attacks did a lot to limit banking privacy; but the truth is that banking privacy had been under fire in the United States even before the al Qaida attacks.

In November 1999, Bill Clinton signed into law the Gramm-Leach-Bliley Act (GLBA). One of the major components of GLBA was the creation of **new privacy laws and regulations**.

GLBA requires that financial institutions protect information collected about individuals; but it does not apply to information collected in business or commercial activities.

GLBA's privacy standards regulate what bankers and other financial-services providers can do with the confidential personal information that they collect from clients and customers. Whether these guidelines really do much for individuals is debatable; in this way, the privacy "protections" offered by GLBA are similar to the debatable medical privacy "protections" offered by the HIPAA.

GLBA requires that banks and other firms adopt **written policies for handling confidential personal information** and that they distribute those written policies to all employees. In general, GLBA

prohibits banks and other firms from sharing an individual's confidential information with nonaffiliated third parties, unless:

- they tell the individual in advance that they might share the information with others;

- they give the individual the opportunity to instruct them not to share the information; and

- the individual does not tell them to keep the information confidential.

In banking jargon, the last step—in which the consumer does not tell the bank to keep confidential information confidential—is called "**opting out.**"

Under GLBA, you have to tell your bank not to share your confidential information with third parties. If you don't "opt out," the law presumes that your bank (or other financial services provider) can share your private information.

As with all laws, GLBA uses language in a particular way. GLBA definitions worth knowing include:

- *Customer* and *consumer*. GLBA distinguishes between the two. A *customer* is a person with whom the bank has developed a continuing relationship to provide products or services to be used for primarily personal, family or household purposes. A customer would not in-

clude a person who met with someone from the bank, but then decided not to establish a business relationship with it. That person would be a *consumer*. **Generally, GLBA privacy rules apply to customers...not consumers.**

For example: A person who gets a mortgage from a lender or hires a broker to get a personal loan is considered a customer of the lender or the broker, while a person who uses a check-cashing service is a consumer of that service.

- *Non-public personal information* (NPI) is any information that cannot be found in public sources. NPI is usually obtained directly from the individual; it includes such details as the person's date of birth, Social Security number, financial account numbers and balances, sources and amounts of income, credit card numbers, information obtained about visitors to the bank's Web site and—sometimes—home addresses and telephone numbers.

- An *affiliate* is a company that controls, is controlled by, or is under common control with a bank or financial-services provider. A *nonaffiliated third party* is any person or entity other than the bank, its employees or an affiliate.

- A *joint marketer* is a company that markets bank products or services under a joint agreement with one or more financial institutions. A *service provider*

> is a company that assists a bank in administering, processing or servicing a customer's account.

Under GLBA, banks and financial service providers must give customers **either a full notice or simplified notice** of privacy policies. The banks must provide the full notice if they disclose or reserve the right to disclose customers' NPI to any third party—including affiliates—unless the disclosure is permitted under certain exceptions.

What are these exceptions?

There are no opt-out rights for disclosures of NPI a bank makes to service providers or joint marketers; but the bank must disclose the nature of any information to be shared and must enter into contractual arrangements to **require the third party to maintain confidentiality** of the information.

Most government agencies enforcing the GLBA have a difficult time **explaining the "opt out" concept in understandable terms.**

Here's an example of State of Washington administrative report suggesting GLBA-compliant policy language for banks to use:

> If you prefer that we not disclose confidential personal information about you to non-affiliated third parties, you may opt out of those disclosures; that is, you may direct us not to make those disclosures (other than disclosures permitted by law).

> The most important thing, related to privacy, to
> remember about GLBA is its notion that consumers
> have to ask their banks not to give away personal
> financial information. This is virtually nonsense and
> an outrageous presumption in banks' favor.

Why should consumers have to ask banks not to
share personal information? Banking laws ought to
presume that banks won't do that.

PANAMA FOR PRIVACY

Because of laws like GBLA and the Patriot Act—
and because traditional privacy jurisdictions have
weakened their laws—Panama has become a favor-
ite domicile country for many privacy advocates and
money managers.

Panama has no tax treaties with other countries;
it is nearly unique in this respect. In Panama, all
tax offenses are considered civil offenses—which is
good for account-holder privacy. The country of-
fers other advantages for privacy-minded investors:

- Collection of civil judgments from for-
 eign countries is difficult, time consum-
 ing and expensive.

- Panama has no treaties recognizing civil
 judgments, child support or alimony
 ordered by foreign courts.

- Panamanian "dead anonymous Bearer
 Share Corporations" have no registry or

database which records ownership of the corporation. The ownership of the corporation is based on who physically has the stock certificates.

- Panama also allows anonymous foundations with no registry or database to record ownership.

The **bearer-share corporations** and **anonymous foundations** are considered separate persons by Panamanian law. So, when bank wires move to and from the account of a bearer share corporation or anonymous foundation, no one can determine who the natural persons are behind the transactions.

Panama banking laws rely on a Swiss-based international industry group—the **Basel Committee on Banking Supervision**—to oversee industry regulations and policies.

> Panama's desire to make itself a privacy jurisdiction also extends to very strong attorney-client privilege laws. Under Panamanian law, a lawyer or law firm can't reveal anything about a client or that client's transactions or business dealings—unless specifically authorized by the client.

There are many nonlawyer consultants and companies that offer to set up foundation/corporation structures in Panama. They can do this, legally. But nonlawyers aren't covered by Panama's **attorney-client privilege laws**—so, they can be forced to divulge the personal information of their clients.

Even if you haven't broken any law, legal adversaries can attack U.S. attorney-client privilege with allegations that your attorney conspired or was complicit in some way in the fraudulent conveyance of assets, tax violations of other wrongdoing.

> American lawyers don't like facing such allegations, even if they are untrue, and may hand over private information to avoid even the appearance of wrongdoing. The lawyers may consider this behavior "ethical"—but it may not be in a client's best interest.

SWISS BANK ACCOUNTS

Even though Panama is a recent favorite, Switzerland remains the preferred "privacy jurisdiction" among money managers. And it's worth considering in some detail *why* this remains so.

Switzerland has laws to prevent obviously criminal proceeds from being sheltered in its banks. But—as in Panama—tax evasion is not a crime according to Swiss law. Therefore, **a tax evasion conviction in a foreign country will not penetrate Swiss banking secrecy laws**.

There are a number of other reasons why Swiss bank accounts remain popular among privacy advocates. The Federal Constitution of the Swiss Confederation and the **Swiss Banking Act** guarantee the right to privacy—including, but not limited to, Swiss bank account privacy.

The following language is taken directly out of the Swiss Constitution:

Article 13: Right to Privacy

1 All persons have the right to receive respect for their private and family life, home, and secrecy of the mails and telecommunications.

2 All persons have the right to be protected against the abuse of personal data.

Also, Article 47 of the **Swiss Banking Act** provides for criminal sanctions (including imprisonment up to six months) against anyone who **divulges confidential information** entrusted to him or of which he has become aware in his capacity as an officer or employee of a bank.

> **So, the Swiss banker is specifically obligated to protect and guarantee the confidentiality of the client's Swiss bank account.**

Who can open a Swiss bank account? Theoretically, *anyone* **can**. And a corporation or limited liability company (based elsewhere) can be the legal owner.

But, mindful of their reputations, most Swiss banks will check out people or firms who want to open accounts. Swiss law prohibits a bank from opening an account if it knows—or even suspects—that **the funds come from criminal activity**.

To this end, some banks require the party opening an account to make a personal visit, to provide official identification and confirm the legitimacy of the funds being deposited.

> Other banks may send an officer to the applicant's home or business to conduct the in-person interview. Still others may allow a foreigner to open an account without making a personal visit—if the foreigner hires a Swiss lawyer or agent to help confirm identity and legitimacy.

In any case, opening a Swiss bank account will involve at least four steps:

1. You will need to **complete the application** forms that are required by the bank. You may be required to show receipts and other paperwork related to other banking transactions that you have made.

2. A bank officer will need to see a current passport, driver's license or other **government-issued identification** documents.

3. The bank officer may also need to see **proof of source of funds**—such as the contract for the sale of a business or real estate, a recent bank statement from your existing bank or a receipt from the sale of stock.

4. If the account is opened in a company name, **company documentation** must be provided in addition to the identity information required of the person or people behind the company.

For most banks there is a minimum initial balance of between $500,000 and $2.5 million. However, some Swiss banks will open an account for $100,000 or even less.

You can designate your account to be denominated in U.S. dollars, euros, Swiss francs or most other major currencies.

FRAUDULENT CONVEYANCE

There is one major limitation to Swiss asset protection. Creditors may seize money in a bank account or insurance policy assets if they can be declared invalid as a result of **fraudulent conveyance**.

> Fraudulent conveyance can usually be established if the account-holder or policy-owner has transferred funds in less than 12 months before declaring bankruptcy or having assets seized as part of a collection procedure at home. It can also be proven if the account-holder acted with the "clear intent" to damage creditors.

For most people, the complexities of offshore solutions for financial privacy protection can be daunting. Investors looking to protect their assets through

offshore banking need to do homework to find the right offshore account or domicile for their needs.

But, in the wake of laws like the Patriot Act, **moving at least some of your money abroad** may make the best sense.

13

DIRECT MARKETING & SPAM

If you buy a product or subscribe to a service, can you expect your name and contact information to be kept private? Not unless **the company keeping your name says explicitly that it will do so.**

One of the most-often cited precedent cases on the question of direct mail and privacy rights is the 1996 Virginia decision *Ram Avrahami v. US News and World Report, Inc.*

In April 1995, *US News & World Report* sent a list of 100,000 of its subscribers' names and addresses to the marketing department of *Smithsonian* magazine. This transaction was part of an **ongoing list exchange** agreement between the two magazines. The list exchange was for purposes of trade: *US News* wanted to sell subscriptions to readers of *Smithsonian* magazine; *Smithsonian* magazine wanted to sell subscriptions to readers of *US News*.

By exchanging subscriber lists, the two publications acquired the names and addresses of prospective new customers to whom they could send promotional materials.

The mailing list shipped by *US News* included Ram Avrahami's name and address, although his name was misspelled "Ram Avrahani" on that list.

> **Avrahami had intentionally misspelled his name when he subscribed to *US News* so that he could identify it as the source of any mail solicitations he received with his name misspelled in that way.**

Avrahami received an offer from *Smithsonian* magazine, addressed to his home with his name misspelled "Avrahani." Later, he received other direct-mail offers with his name misspelled the same way.

Avrahami—who considered himself a privacy advocate—sued *US News* under **a Virginia law usually used by celebrities that prohibits the misappropriation of one's name for commercial purposes**. He asked the court for an injunction restraining *US News* from continuing to sell, lease or trade his name without his consent.

The Virginia statute that Avrahami cited states:

> Any person whose name, portrait or picture is used **without having first obtained the written consent** of such person ..., for advertising purposes or for the purposes of trade, such persons may maintain a suit in equity against such person, firm or corporation so using such person's name, portrait or picture to prevent and restrain the use thereof...

The statute also provides that a person aggrieved by the unlawful use of his name may recover his **actual damages** and, if the marketer "knowingly" used his name, **punitive damages**.

According to the Virginia Supreme Court, the state law "creates in **an individual a species of property right** in their name and likeness." And the state Supreme Court had also ruled that Virginia's privacy act applies to two different types of commercial activity. It prohibits the unauthorized use of a person's name either for "advertising" or for "purposes of trade." These are "separate and distinct statutory concepts."

Therefore, Avrahami argued, *US News* violated the statute if it used his name without his consent for either purpose. And:

> The object of the List Exchange Agreement was to permit each publication to send promotional materials through the mail to the other's subscribers. Therefore, Mr. Avrahami is entitled to recover under the "advertising" branch of the privacy act. ...By exchanging Mr. Avrahami's name for something of value, *US News* committed the tort of conversion, the civil wrong that occurs when "a defendant uses another's property as its own and exercises dominion over it without the owner's consent."

US News asked the court for a declaratory judgment that it could continue to sell, lease and trade Avrahami's name, whether or not he had consented. It cited three cases supporting the proposition that

courts "have uniformly found that no rights of the individuals whose names are on the lists results from the exchange of mailing lists."

The magazine also argued that Avrahami had no privacy interest in his name because his name had been printed in the telephone book.

This argument provoked a particularly strong response from Avrahami. He argued

> ...The object of the privacy act is not to protect names. A name is only a symbol for a person. **The true object of the privacy act is to protect a person from an "unauthorized exploitation of his personality for purposes of trade."**

In June 1996, Judge William T. Newman accepted without comment the position of *US News* in its legal battle against Avrahami. This ruling agreed with *US News* that the use of one name in a mailing list is **too incidental to be actionable** under Virginia statute and does *not* constitute a use for advertising purposes or for purposes of trade.

However, Newman didn't agree with everything *US News* said. He explicitly did not accept three parts of the magazine's legal argument:

1. that the sale of a mailing list does not violate individuals' privacy;

2. that the sale of a mailing list can not

cause harm to the people on the list; and

3. that prohibiting the exchange of mailing lists is a violation of the First Amendment to the U.S. Constitution.

So these points might work in other situations.

MARKETING MEDICAL DATA

In the HIPAA chapter of this book, we looked at how people wrongly assume that their personal information in medical records and charts will be kept private. And we also looked at a lawsuit involving the big pharmacy chain Albertsons—and allegations that it had improperly **used patient information in marketing deals** with drug companies.

The Albertsons case is worth another look, from a direct-marketing perspective.

According to the **Privacy Rights Clearinghouse** (one of the main parties in the lawsuit against Albertsons).

> Albertsons collects its customers' confidential medical information by surreptitiously reviewing customer prescriptions—required to be kept confidential and used only as authorized by the patient—and creates a retrievable database including customer addresses, phone numbers and drug regimen. The information is made available for use to satisfy pharmaceutical companies willing to pay Albertsons to fulfill drug marketing objectives.

The result is unsolicited mailings and/or phone calls directed at consumers attempting to convince them to buy more or different medications.

According to the PRC, Albertsons represented on its Web site that it protected customer privacy—and then disregarded that promise.

Here's how its marketing deals with drug companies work:

- Consumers provide confidential medical information to Albertsons for the purpose of filling their prescription(s). The customer is not advised or informed it will be **used for other purposes**.

- The confidential medical information includes the customer's name, address, telephone number, the medication prescribed and, by deduction, the underlying medical condition.

- Albertsons enters into commercial arrangements with pharmaceutical companies willing to pay to participate in the Drug Marketing Program—which uses the confidential information for direct marketing to increase the sale of specific prescription drugs.

- The drug companies prepare and/or have final approval of the text of direct marketing letters or phone calls. The letters are sent to pharmacy customers under Albertsons' letterhead. The communications aren't shared with the cus-

tomers' doctors; and customers are never told that the solicitations have been prepared by drug companies.

The Albertsons direct mail pieces offered consumers the chance to "opt-out" and not receive further letters; however, relevant state law specified that **the only acceptable procedure was for a customer to "opt-in"** before direct mail was sent.

Drug companies participating in the program paid Albertsons for retrieval of customer profiles and achievement of objectives. Albertsons received an amount per letter; some contracts provided an additional **incentive fee for successful results**.

According to the PRC, Albertsons concealed the purpose of the drug marketing program from its customers. It **disguised the direct marketing campaign** as being for the purpose of reminding consumers to renew their prescriptions or informing them of alternative drugs that were available for their medical conditions.

> **If you receive a letter or phone call from your pharmacy in which you are advised to switch to a certain brand, it is likely that your pharmacy has entered into a marketing program similar to Albertsons' drug marketing program.**

But **programs like this aren't necessarily illegal**. Not all states require pharmacies to notify you before using your information for direct marketing.

Ask the professionals at your pharmacy if they sell or share personal information with any other companies before you decide to do business with them. If they say "yes," either find another pharmacy or **instruct your pharmacy in writing** to not sell, share or use any personal information with other companies, affiliates or business partners. **Ask for written confirmation that they will not do so.**

Be sure to read the **privacy notice**, often called an "HIPAA notice," of any pharmacy that you use.

THE "CAN-SPAM" ACT

So far in this chapter, we have concentrated on direct marketing campaigns that use physical mail or telephone calls. Of course, the fastest-growing method of direct marketing uses a different medium—electronic mail.

Unwanted, unsolicited e-mail, commonly known as "spam," comprises an increasing percentage of the e-mail messages sent and received online every day. Some Internet researchers suggest that spam represents more than 90 percent of all e-mail messages traveling across the Internet.

> **The increasing volume of spam increases the costs borne by ISPs, tarnishes the Internet experience of their customers and constituents, invades individual users' privacy—and even threatens to overwhelm the global e-mail network.**

To set some controls on this threat, in 2003 the U.S. Congress passed the Controlling the Assault of Non-Solicited Pornography and Marketings ("CAN-SPAM") Act. The CAN-SPAM Act is intended to protect privacy. Does it? To find out, let's consider a precedent decision involving the law.

In November 2006, the U.S. Court of Appeals for the 4th Circuit issued its ruling in *Omega World Travel, Inc., et al. v. Mummagraphics, Inc., et al.* That ruling defines how the CAN-SPAM Act can be used. It was, essentially, **a major win for spammers**.

Mark Mumma owned and operated an Oklahoma-based Web site design firm called Mummagraphics. Through his company, Mumma also ran several anti-spam Web sites. Between late December 2004 and early February 2005, a **general-delivery e-mail address** at one of these sites received 11 e-mails about "E-deals"—offers for cheap travel packages—from a site owned by Omega World Travel.

As the court would later note:

> Each message contained a line of text on which the recipient could click in order to be removed from future mailings, and each message also said that the recipient could opt-out of future e-mails by writing to a postal address contained in each message. Each message also contained a link to the [Omega World Travel] and a toll-free phone number for the company.

Mumma didn't use the electronic opt-out link to remove his address from the e-mail list; instead, he called John Lawless, Omega World Travel's general

counsel, to complain. Mumma told Lawless that he had not asked to receive the "E-deal" messages and that he refused to use e-mail opt-out mechanisms because "only idiots do that." He believed **opt-out mechanisms just led to more unwanted messages**. Mumma told Lawless that his preferred removal procedure was to sue.

Lawless asked Mumma for his e-mail address, but Mumma refused. Instead, he asked Lawless to remove from all future mailings **every address containing any domain name listed** on Mummagraphics' "OptOutByDomain.com" site.

> **Lawless said he would take the addresses down right away; but the addresses weren't immediately removed from Omega's lists.**

The day after speaking with Lawless, Mumma received another "E-deal" message. He sent a letter dated January 25, 2005 to Daniel Bohan of Omega World Travel, saying that he'd received six unsolicited "E-deal" messages from Omega. The letter claimed that the messages violated federal and state laws and said that **Mumma intended to sue Omega for at least $150,000 in statutory damages unless Bohan settled the matter for $6,250**.

Mumma attached hard copies of the offending e-mails to his letter. Lawless, Omega's lawyer, noticed Mumma's e-mail address from the printouts and **ordered that the address be removed from Omega's mailing lists**. It was.

Omega World Travel didn't pay Mumma the money he demanded. Soon after, a series of postings on one of Mumma's anti-spam Web sites accused Omega and owners Daniel and Gloria Bohan of violating state and federal laws. The Web site **posted a photo of the Bohans** (apparently copied from the Omega Web site) and **described the couple in unflattering terms**.

On the basis of these postings, **the Bohans sued Mumma in federal court**, claiming defamation, copyright infringement, trademark infringement and unauthorized use of likeness. The trial court dismissed all of the claims except the defamation action. That matter proceeded to trial.

Mumma countersued the Bohans, making various claims under Oklahoma and federal law—including **the CAN-SPAM Act**. The trial court dismissed all of his claims, concluding that Omega had not violated the CAN-SPAM Act because it had provided opt-out features in its e-mails and alleged inaccuracies in the e-mails were not material.

Mumma appealed. The appeals court agreed with the lower court. It wrote:

> The e-mails at issue were **chock full of methods** to "identify, locate, or respond to" the sender or to "investigate [an] alleged violation" of the CAN-SPAM Act. Each message contained a link on which the recipient could click in order to be removed from future mailings, in addition to a separate link to [Omega]'s Web site. Each message prominently displayed a toll-

free number to call, and each also listed a Florida mailing address and local phone number for the company.

The CAN-SPAM Act **doesn't ban all commercial e-mails**. And it doesn't impose strict liability for insignificant inaccuracies. On the contrary, Congress acknowledged the "unique opportunities for the development and growth of frictionless commerce" and the "convenience and efficiency" that unsolicited e-mail advertisements present.

Instead, **Congress targeted e-mails containing something more than an isolated error**. The CAN-SPAM Act requires that the commercial e-mails it covers include:

> a functioning return electronic mail address or other form of Internet-based mechanism, clearly and conspicuously displayed, that... a recipient may use to submit, in a manner specified in the message, a reply electronic mail message or other form of Internet-based communication requesting not to receive future commercial electronic mail messages from that sender at the address where the message was received....

Senders must honor requests for removal made using these mechanisms within 10 business days. The court found that **Omega had followed these rules**.

Mumma made another argument that—although it didn't work in his case—is an interesting legal theory for protecting your privacy. He claimed that Omega World Travel's e-mail messages amounted to **trespass to chattel** under Oklahoma law.

Trespass to chattel is a common law tort that "may
be committed by intentionally (a) dispossessing
another of the chattel, or (b) using or intermed-
dling with a chattel in the possession of another."

However, trespass to chattel claims may be brought
against a trespasser only if

- he dispossesses the other of the chattel,

- the chattel is impaired as to its condi-
 tion, quality or value,

- the possessor is deprived of the use of
 the chattel for a substantial time, or

- bodily harm is caused to the possessor,
 or harm is caused to some person or
 thing in which the possessor has a le-
 gally protected interest.

The appeals courts rejected this argument because
Oklahoma courts had never recognized it based
upon intangible invasions of computer resources.
In fact, one Oklahoma court had described "inter-
meddling" with a chattel as meaning "intention-
ally bringing about a physical contact with the chat-
tel" and **would not allow "an action for nominal
damages for harmless intermeddlings."**

However, the federal appeals court allowed that the
claim might work if the party making it showed "a
**meaningful burden on the company's computer
systems** or even its other resources."

> So, trespass to chattel might be a useful claim to make in suing someone who damages your computer systems with privacy-invading spam.

COMMUNICATIONS DECENCY ACT

Another tool in protecting Internet privacy—and fighting spam—is the 1996 Communications Decency Act (CDA). This U.S. federal law is designed to give ISPs and other access providers freedom and legal protections to filter and block spam and other privacy-invading communications.

The CDA states:

> (1) No provider or user of an interactive computer service shall be treated as the publisher or speaker of any information provided by another information content provider. (2) No provider or user of an interactive computer service shall be held liable on account of (A) any action voluntarily taken in good faith to restrict access to or availability of material that the provider or user considers to be obscene, lewd, lascivious, filthy, excessively violent, harassing, or otherwise objectionable, whether or not such material is constitutionally protected; or (B) any action taken to enable or make available to information content providers or others the technical means to restrict access to [such] material....

Under the CDA, an "interactive computer service provider" is defined as:

> a service or system that provides access to the Internet and such systems operated or services operated by libraries or educational institutions.

So, ISPs, libraries and schools are immune from liability for "action[s] voluntarily taken in good faith to restrict access to or availability of material that the provider or user considers to be...harassing, or otherwise objectionable"—**in other words, blocking spam**.

> If you're being harassed by spam and other unsolicited Internet marketing materials, forward the e-mails to your ISP with a request that it uses its legal tools for blocking the junk.

TIPS FOR GETTING RID OF SPAM

* Accustom yourself to using personal and work e-mail addresses. For your personal address, use any of the major free e-mail services (including HotMail, Yahoo and GMail)—and plan to change it every six to 12 months. This may create some inconvenience for people who send you e-mails once a year or less often; but it adds a major level of privacy protection for you.

- To minimize spam in free e-mail accounts select user names as follows: Make up two names—for example, Harry Doyle; in between these two names insert a four digit number so the address becomes something like harry1996doyle@yourISP.com.

- If at all possible don't post your personal e-mail address on the Internet and—if you do—consider displaying it in a format only humans can decipher such as: john1964doe # hotmail.com (and tell readers "replace # with @ to e-mail me").

- Make sure your free e-mail account allows you to turn off "display html". People can send your anonymous account a one-pixel image which will give them a log file on the server serving the image of your IP address.

CHAPTER

14

PRIVACY IN THE
WORKPLACE

In March 2007, Wal-Mart Stores Inc. fired an employee for illegally recording a newspaper reporter's phone calls to the company. According to Wal-Mart, the employee had violated the reporter's privacy.

Brian Gabbard—the fired employee—promptly claimed that he'd been part of a larger, sophisticated surveillance operation that included snooping not only on employees but also on Wal-Mart critics, stockholders and outside consultants.

Gabbard said Wal-Mart made a practice of using aggressive "security" tactics. It planted undercover employees in anti-Wal-Mart groups; and it deployed cutting-edge electronic monitoring systems made by a supplier to the Defense Department that allowed it to record the actions of anyone connected to its global computer network.

After the company fired Gabbard, a 19-year employee, it conducted an internal investigation of his

group's activities, fired his supervisor and demoted a vice president who'd overseen the group.

> Gabbard said that he recorded the reporter's calls on his own because he felt pressured to stop leaks of company information. But he said that most of his spying activities were sanctioned by superiors.

A Wal-Mart spokeswoman, Sarah Clark, disagreed that the company's security operations were aggressive or unusual. In a statement, she said:

> Like most major corporations, it is our corporate responsibility to have systems in place...to monitor threats to our network and our intellectual property so we can protect our sensitive business information. It is also standard practice to provide physical and information security for our corporate events and for our board of directors and senior executives.

Still, retail industry analysts noted that Wal-Mart had developed a reputation for aggressive monitoring of employees and others. The Gabbard episode only confirmed what many in the retail sector already suspected—that **workplace privacy was not a corporate priority for the giant retailer**.

NO MORE "SECRET LIVES"

When it comes to privacy in the workplace or related to work, people seem to get into trouble when

they expect privacy that they don't actually have. Sometimes, this results from **confusing privacy with anonymity**—a mistake we've seen before. Sometimes, it comes from compartmentalizing life or life-style; that is, assuming actions or behaviors in one context will never affect another.

> In the Internet era, compartmentalizing your life is an ill-advised thing to do. It presumes anonymity, which—as we've seen before—isn't a smart move.

In April 2007, a woman sued Pennsylvania-based Millersville University after it denied her a teaching degree because of **pictures posted to the MySpace.com Web site that showed her drinking alcohol**.

The photos, which had been taken at a 2005 Halloween party, were posted to Stacy Snyder's own MySpace.com page. (Whether Snyder posted them herself was unclear, though she was aware of them.)

One of the pictures—captioned "Drunken Pirate" showed Snyder wearing a pirate hat while drinking from a large plastic cup.

The University informed Snyder the day before her graduation that, because of what it had characterized as **"errors in judgment"** and **"unprofessional" behavior on her part**, it would not grant her a degree in Education and the teaching certificate she was expecting. Instead, it granted her a degree in English.

According the Snyder, the dean of the University's School of Education said the pictures promoted underage drinking—even though **Snyder was in her mid-20s when the pictures were taken**.

In its response to Snyder's charges, the University argued that its evaluation of her as "unprofessional" related to her performance as an apprentice teacher at a nearby high school (a standard element of the University's education degree). In this context, it claimed, Snyder was **more like a public employee than a student**; and, as a public employee, she had less expectation of keeping a "private" Web page.

The University's argument would probably come as a surprise to thousands of other public employees in Pennsylvania. But it's part of a long line of arguments public-sector employers make that their employees expect too much privacy at work.

Other cases in this long line include:

- *McVeigh v. Cohen*. In this 1998 case, the U.S. Navy discharged an officer for violating its "Don't Ask, Don't Tell" policy. The discharge was based on information the Navy obtained from AOL in violation of the Electronic Communications Privacy Act. The federal trial court suppressed this evidence and suggested that the Navy's initiation of its investigation based on statements appearing on the Internet and attributed

to the officer was not appropriate. According to the court, such statements were of limited value because the Internet's "virtual" nature invites fantasy and affords anonymity.

- ***Raytheon, Inc. v. Doe***. In February 1999, Raytheon filed suit against 21 employees it alleged had posted or discussed confidential corporate information on a Yahoo message board, in violation of their employment contracts and Raytheon's published employment policy. Raytheon also claimed that this conduct constituted misappropriation of its trade secrets. To identify the "John Does," Raytheon sought—and received **—a court order allowing its lawyers to take discovery from Yahoo, AOL, Earthlink and various other ISPs,** seeking information identifying the 21. Yahoo, after being served with a subpoena, identified the posters. In May 1999, Raytheon dismissed the action, after several of the posters resigned.

In each of these cases, the employer argued that its status as a public-sector entity (or contractor, in Raytheon's case) meant **its employees had less expectation of privacy** in their online postings than other employees might.

WORKPLACE SURVEILLANCE

According to a 2006 survey by the American Management Association and ePolicy Institute, **more than 75 percent of employers monitor their**

workers' Internet activity. About half of all workplaces review computer files; and 36 percent track keystrokes and the time spent at the keyboard.

> **Shrinking expectations of privacy at work aren't all the fault of spying bosses; on-the-job surveillance has gotten easier since anyone with access to Google can investigate their coworkers or employees.**

Some firms are resorting to metal and bug detectors to scan employees entering private meetings. Others ban cell phones and BlackBerrys at high-level meetings.

And **don't think you're immune from surveillance** just because you're a senior executive or a board member. While there are no surveys quantifying surveillance on C-level executives, it makes sense to target those handling the most sensitive data.

As corporate security professionals often point out: **It's difficult to protect yourself from someone who wants your personal information.**

In the Hewlett-Packard pretexting case, the investigators hired by Patricia Dunn didn't seem constrained by decency, common sense or even budget. Along with scrutinizing phone records, they watched people's homes and even thought about **planting spies disguised as janitors** in the offices of the *Wall Street Journal* and CNET.com.

H-P executives seemed interested in exposing one journalist—CNET.com reporter Dawn Kawamoto—in particular. Senior counsel Kevin Hunsaker apparently oversaw the investigation; he created a fictitious H-P employee who would leak inaccurate information to Kawamoto. By including a "tracer" program in the fake employee's e-mail, Hunsaker hoped to track anyone Kawamoto contacted with the bogus news.

The e-mail tracer software didn't work.

DOES *EVERY* COMPANY SPY?

Just about every publicly-held company worries about leaks. So, company managers check employee phone calls and e-mails.

In the U.S., companies can—and do—monitor e-mail....routinely. No one should assume that any phone or e-mail coming into or leaving from an office or company-owned computer is "private."

Some companies let employees know that their communications are monitored; others are less direct. At Apple Computer, CEO Steve Jobs has lashed out at those suspected of dealing in leaked Apple information. In January 2005, Apple sued a Web site—Think Secret—run by a then-19-year old, for allegedly soliciting insider information from Apple employees and publishing it on the site.

Zero privacy and zero trust are the standards modern of corporate management. Smart employees assume that no conversation at work is ever private; outsiders—journalists, analysts and consumers—have to consider whether news is fabricated and interviews covertly monitored.

BACKGROUND CHECKS

As the Internet economy matures, companies will find it increasingly important to hire honest employees—although companies will have to investigate employees and job applicants more thoroughly then ever in order to do so.

> **Past behavior is widely considered to be the best predictor of future behavior—though it is not a perfect indicator.**

As long as investigations and background checks are done **with the applicant or employee's knowledge and permission**, they aren't an invasion of privacy.

However, **some companies may be tempted to do the checks** *without* **permission**—which will create legal and ethical privacy problems.

There isn't a lot of law controlling employers background checks (at least for private-sector employers). The best guidance comes from federal **anti-discrimination laws** and—to a lesser extent—from **consumer-protection and privacy laws**.

In U.S. workplace antidiscrimination law, job descriptions and other employment standards are supposed to be based on bona fide occupational qualifications (BFOQs)—skill, education and performance standards that can be linked clearly to the proven necessities of a job.

So, background checks should also correspond to the bona fide requirements of the job in question.

If the job involves handling sensitive personal information—especially financial or health information—of customers or employees, **a full criminal background check** is probably a reasonable policy.

But, if the job does not involve handling personal information, a simple credit report should give an employer a useful perspective of an applicant.

When an employer orders a background check on a prospective or current employee, federal law requires that it notify the person (in writing) that it will use a credit report and obtain consent to do so. This process is **a key element of compliance with the Fair Credit Reporting Act (FCRA).**

Applicants and employees should be aware that, in the 2000s, employers—especially those hiring high-profile, executive positions—have become **extremely sensitive about accuracy in resumes and work histories** of job applicants.

> A number of highly-publicized cases of executives "padding" their resumes and claiming academic degrees they didn't actually earn have created a boom in demand for out-sourced background checks.

One way that employers can minimize privacy problems is to stay in communication with the applicant or employee being investigated. If a background check turns up troubling information, the employer should **give the applicant or employee a chance to explain or correct the information** before making a hiring decision.

If an employer rejects an applicant or terminates a current employee based on something in the employee's report, the **FCRA requires the employer to state that it has done so for this reason.**

PROTECTING PERSONAL DATA

The other side of privacy issues at work is protecting the privacy of clients and customers. (Most privacy advocates say that a company that protects the privacy of its customers will also respect the privacy of its employees.)

> Whether it comes from providing a complex service, completing a financial transaction or creating a mailing list, customer data has become a key currency of the information-based economy.

Privacy management may seem overwhelming—but you don't need to become a privacy expert to manage it. All you need to do is have **a basic understanding of the issues** and the business tools that will protect customers...and employees.

Here are some examples of how existing privacy laws may affect the way a company does business:

- As we've noted before, any company that uses credit reports to evaluate potential customers or employees must comply with the FCRA That means the company has to have the consent of the person or company it's checking out; and it has to let either know if the credit report was the reason for a negative decision.

- Any company operating in the health care field must follow the privacy requirements of the federal HIPAA Privacy Rule and its data security requirements. However, as we've noted before, the HIPAA Privacy Rule protects database owners as much as individuals.

- As we've noted before, companies in the financial services field must comply with rules established by the Gramm-Leach-Bliley Act (GLBA). Companies that need to comply with GLBA include those that might not necessarily think of themselves as "financial"—such as automobile dealers, tax planners and some travel agents.

FIREWALLS ARE NOT ENOUGH

You might think that the right combination of hardware and software will prevent data breaches and privacy exposures. But technology is just one piece of the privacy equation. Smart companies also have **clear data-management policies**—and they train their employees in these policies.

Technology can't prevent employee error.

> **Consider this example: Company X equips its computers with the latest security software—firewalls, encryption programs, etc.—and senior management relaxes because it has "strong security." One day a "customer" calls Company X's service center to ask what credit card he has on file for his account. The caller gives his name and address to an employee who looks up the account in the main customer database. The information the caller provided checks out, so the employee reads the credit card number back. The caller says everything is fine and thanks the employee. But the caller is not a customer; he's an identity thief who found the name and address on a Company X invoice in a trash bin.**

Modern technology has created **privacy exposures** that companies need to secure. Personal information may include names, addresses, account numbers, Social Security numbers, credit/debit card numbers and phone numbers—as well as account patterns and transaction records.

Once you identify your security needs, you can begin to **write a security and privacy policy** for your company. Your security and privacy policy tells your customers how you will treat their personal information—how you will collect it, use it, and keep it secure. It should also give your customers the ability to communicate to you **if they wish to receive ("opt-in") or not receive ("opt-out") information** from you and how they wish to receive marketing communications (e-mail, U.S. mail, etc.).

Smart companies offer meaningful privacy choices and carry them out effectively. Those that don't risk losing customers.

The **Direct Marketing Association** (DMA) offers a business-friendly online privacy policy generator at the Web site http://www.the-ddma.org/privacy/privacypolicygenerator.shtml.

DISPOSING OF CUSTOMER DATA

The type of information you collect from your customers depends on your individual business—and can range from a customer's name, address, telephone number and e-mail address to significantly more personal information—such as credit/debit card numbers, account numbers, transaction summaries, consumer credit reports, etc.

If you collect and store credit card information, you need to follow security rules set by the major credit card companies.

> **For small businesses: If you don't absolutely need a piece of customer information, don't collect it.**

Collecting customer data you do not need increases security and privacy risks. Companies should be particularly careful about **collecting and storing** financial and personally identifiable information—including Social Security numbers, credit and debit card numbers or driver's license numbers. Some other useful tips:

- Check your payment transaction software to determine whether **it collects personal data you don't even realize,** such as the magnetic strip or PIN information from a payment card. If you have customer data you no longer need, discard it—securely.

- Purge the hard drives of any old computers or laptops before storing or disposing of them.

- Guard against both **high-tech and low-tech opportunists**. If your operations are not kept physically secure, anyone can walk in and steal unprotected customer data from your cabinets, drawers and desks.

- Review whether your employees have access to personal information they don't need to do their jobs. As we've seen, many data exposures stem from

employee access to personal data that was inconsistent with or not necessary to their job descriptions.

Disposing of personal data also is an access point for data/identity thieves. Sloppy security practices in data disposal can lead to theft. The federal government issued a **Disposal Rule amendment** to the FCRA, called the Fair and Accurate Credit Transactions Act (FACT Act).

Through these rules, the FTC requires **all businesses—no matter what size**—that manage credit data to take steps to prevent discarded customer information from unauthorized use.

For more information on the Disposal Rule, you can see the FTC Web page www.ftc.gov/bp/conline/pubs/alerts/disposalalrt.htm.

The FTC Disposal Rule applies only to information businesses get **from credit reports**. However, it makes sense to follow sound data management (and disposal) practices—whether or not the law specifically requires it.

SIMPLE DATA SECURITY TIPS

Sole proprietors, professionals and other small businesses often think they're not likely targets for data theft or customer information leaks. This may be true, statistically—but even one leak of client information can damage the reputation of a small

business. So, here are **some common-sense tips** that any individual or small business can use to keep personal data relatively secure:

- Keep customer account records and other personal information in locked cabinets.

- Don't leave papers or files unattended on desktops.

- Never leave a business premise open and completely unattended, even for a short time.

- Use a locked mailbox or a post office box for incoming and outgoing mail.

- Use security envelopes for bills or other mail containing personal information.

- Shred anything with customer or employee personal information before discarding it.

15

TRAVEL AS A
PRIVACY ISSUE

Few people think of travel as a privacy issue—but it is. Freedom of **movement without having to provide personal information** is an essential American liberty; efforts to restrict that liberty are erosions of privacy.

And these efforts to restrict don't have to take the form of **soldiers demanding to see your "papers."** They can be government agencies tracing your credit card activity from a distance.

> So-called "dataveillance"—surveillance of data about people's actions—can threaten your privacy as much as human or video camera surveillance. The information it collects is different, but the consequences are the same.

Law professors explain that the First Amendment protections of **free speech and assembly imply a right to move around freely within the U.S.— and to travel outside of it, as you wish.** However, in

the post-9/11 era, travel is something that security and law enforcement agencies watch. In addition to "listening in" on telephone conversations, the National Security Agency uses computer algorithms to sift through consumer travel data looking for suspicious activity.

The most concrete example of the government restricting travel is the **watch list** (sometimes called the **"No Fly list"**) developed by the NSA and Federal Aviation Administration and used by the Transportation Security Agency. The list includes thousands of names of people who—for various reasons—may pose risks to commercial air flights.

As we'll see in greater detail later, the FAA/TSA watch list doesn't do much to make airline flights safer; but it definitely invades the privacy of the people whose names appear on it. And it doesn't give them much opportunity to contest or appeal their inclusion on the list.

These invasions of privacy are likely to continue. In June 2004, a federal judge in Minnesota **tossed out a privacy lawsuit** against Northwest Airlines. A group of Northwest customers were claiming that their privacy had been violated when the airline gave their personal information to the government.

According to the passengers, after 9/11 the National Aeronautical and Space Administration (NASA) asked Northwest to provide certain passenger information in order to assist NASA in studying ways

to increase airline security. Northwest supplied NASA with passenger name records (PNRs).

> PNRs contain information such as a passenger's name, flight number, credit card data, hotel reservation, car rental and any traveling companions.

The passengers claimed that Northwest's actions violated the **Electronic Communications Privacy Act (ECPA)**, the FCRA and Minnesota's Deceptive Trade Practices Act—and constituted invasion of privacy, trespass to property and **intrusion upon seclusion**.

The basis for most of the claims was the fact that Northwest's Web site contained a privacy policy that said **Northwest wouldn't share customer information** except as necessary to make travel arrangements. The passengers claimed that Northwest's supplying of PNRs to NASA violated that policy.

The trial judge didn't seem to think much of the passengers' claims. In his decision, he wrote:

> Although Northwest had a privacy policy for information included on the Web site, plaintiffs do not contend that they read the privacy policy prior to providing Northwest with their personal information. Thus, plaintiffs' **expectation of privacy** was low.

As we've seen before, invasion-of-privacy lawsuits require the injured party to prove that it had a reasonable expectation of privacy before any damages can be determined.

Next, the judge considered the passengers' claims under the ECPA and FCRA. The ECPA prohibits a person or entity from:

> (1) intentionally access[ing] without authorization a facility through which an electronic communication service is provided; or (2) intentionally exceed[ing] an authorization to access that facility....

The passengers argued that Northwest's supply of personal data to NASA **constituted unauthorized access** to the "facility through which an electronic communication service is provided." The judge didn't agree:

> Defining electronic communications service to include online merchants or service providers like Northwest stretches the ECPA too far. Northwest is not an Internet service provider. In fact, Northwest purchases its electronic communications service from a third party. Under these circumstances, Northwest is simply not an electronic communications service provider, and therefore cannot violate [the ECPA].

He also rejected the passengers FCRA claims and agreed with Northwest's argument that those claims were preempted by the **Airline Deregulation Act**—which *requires* commercial airlines to provide passenger information for a number of reasons, including security.

He ruled that the passengers' claims under Minnesota consumer-protections were also preempted by the Airline Deregulation Act.

Finally, he considered the passengers' **common law claims**—which included: trespass to property, intrusion upon seclusion and others.

COMMON LAW CLAIMS

These claims come up often in invasion-of-privacy cases, so they're worth some detailed discussion.

We've seen the **trespass to property** claim in privacy cases before; in some states, the same concept is defined as "trespass to chattels."

To state a claim for trespass to property, the passengers had to prove that they possessed property, that **Northwest wrongfully took that property** and that they were damaged by that wrongful taking. They argued that personal information contained in the PNRs was their property and that, by supplying that information to NASA, Northwest had wrongfully taken it. The judge didn't agree:

> As a matter of law, the PNRs were not Plaintiffs' property. Plaintiffs voluntarily provided some information that was included in the PNRs. ...when that information was compiled and combined with other information to form a PNR, the PNR itself became Northwest's property.

Intrusion upon seclusion exists when someone

> intentionally intrudes, physically or otherwise, upon the solitude or seclusion of another or his private affairs or concerns... if the intrusion would be highly offensive to a reasonable person.

So, to make a claim for intrusion upon seclusion, you have to show that the alleged intrusion would be highly offensive to a reasonable person. And the trial court hearing your case usually has a lot of discretion in determining whether the alleged intrusion is **sufficiently offensive** to support the claim. When making the decision, the Court will consider the

> degree of intrusion, the context, conduct and circumstances surrounding the intrusion as well as the intruder's motives and objectives, the setting into which he intrudes, and the expectations of those whose privacy is invaded.

Intrusion upon seclusion is an interesting legal theory to use in support of an invasion-of-privacy claim. It exists in many situations which support specific privacy claims; but lay people (and some lawyers) aren't aware of this common-law issue.

In the *Northwest Airlines* case, the judge still wouldn't agree with any of the passengers' claims. On their intrusion-upon-seclusion claim, he ruled:

> the disclosure here was not to the public at large, but rather was to a government agency in the wake of a terrorist attack that called into question the security of the nation's transportation system. Northwest's motives in disclosing the information cannot be questioned. ...the Court finds as a matter of law that the disclosure of Plain-

tiffs' personal information would not be highly offensive to a reasonable person....

The ruling was a complete victory for Northwest Airlines and the federal government—and a complete loss for privacy claims in context of commercial flights in the U.S.

AIRPORT SECURITY: CHECKING ID

The frustration that led the Northwest passengers to sue is understandable. The process of boarding commercial airline flights in the U.S. (and most developed countries) is an erosion of privacy that **does not provide as much security as some people believe** it does.

> Everyone who boards a commercial flight in the U.S. must produce some form of government-issued, photographic identification at least once—when passing through a security checkpoint near the entrance of the airport. However, this requirement is easy to manipulate in a number of ways.

The photo-ID requirement was established by the FAA in 1996; it was a reaction to the explosion of TWA Flight 800, shortly after its takeoff from Kennedy Airport in New York. All 230 people on board the flight were killed—and the cause of the explosion remains a matter of some dispute.

In theory, checking IDs at central security points, assures that everyone on a commercial flight is the

person whose name appears each ticket. There are two problems with this explanation:

1) it's not clear that checking IDs actually accomplishes that assurance; and

2) even if it does, it's not clear that assuring matches between names on government-issued IDs and names on tickets achieves any meaningful security.

Numerous security experts have pointed out that—even with the ID check—it's easy to fly on someone else's ticket.

How? Buy an "e-ticket" through an airline's Web site in the name of a person not on the FAA/TSA watch list; within 24 hours of departure, go back to the airline's Web site and print a boarding pass at home (most U.S. airlines offer this feature). Scan the boarding pass into a digital file and, using any standard graphics software, change the name on it to one that matches a photo ID of the person who will actually be flying. Print a copy of the altered boarding pass, give both boarding passes (original and altered) to the passenger and send that person through security and onto the airplane.

Unless the staff at the security checkpoint have access to the FAA/TSA No-Fly List, they aren't going to stop the passenger. On the way to the plane, the passenger switches to the unaltered boarding pass—which will match the computer record as the airline staff checks the pass at the gate.

This loophole exists because the system that prints out boarding passes is separate from the system that compares the name on the boarding pass to the name on the photo ID. There's no connecting system to make sure that **the name on the photo ID matches the name in the computer.**

And this may not matter: Identification of passengers doesn't increase security very much. **All of the 9/11 terrorists presented photo IDs, many in their real names.**

You give up some privacy when you give personal information to the airline that sells you a plane ticket; you also give up some privacy when you give personal information to the government agency that issues your photo ID. **You may assume that these institutions share that data—but they don't.**

> **The inability of institutions to combine or compare data is one of the major privacy protections that you have in the Internet economy. Most of the time, this lack of coordination works for you. In the case of airlines security, though, it doesn't. You've already given up your personal details in exchange for the promise of security; that promise should be delivered more effectively.**

The problem is simple to fix. The TSA should have at least **one document check station** that simultaneously compares three elements: the boarding pass, a government-issued ID, and the No-Fly List in the airline's computer.

THE GOVERNMENT'S RESPONSE

Unfortunately, the government seems more interested in **maintaining the existing patchwork** of databases than coordinating an effective solution.

One person who pointed out the loophole in the TSA security system was a Ph.D. student at Indiana University named Christopher Soghoian. In 2006, he created a Web site that allowed anyone to create **a fake Northwest Airlines boarding pass**.

Soghoian said that he hoped to bring attention to holes in the TSA's security systems. Explaining his motives, he wrote to the security industry Web site defensetech.com:

> I want Congress to see how stupid the TSA's watch lists are. Now even the most technically incompetent user can generate a boarding pass. ...I don't want bad guys to board airplanes but I don't think the system we have right now works and I think it is giving us a false sense of security.

The Feds didn't appreciate this. A few days later, Massachusetts congressman Ed Markey called for **Soghoian to be arrested**. Markey said:

> The Bush Administration must immediately act to investigate, apprehend those responsible, shut down the website, and warn airlines and aviation security officials to be on the look-out for fraudsters or terrorists trying to use fake boarding passes in an attempt to cheat their way through security and onto a plane.

Later that day, the FBI shuttered the site and met with Soghoian. The next night, Soghoian met again with the FBI for several hours. Whatever he said must not have been convincing. A few hours later—in the middle of the night—FBI agents searched Soghoian's home and seized computers and other personal property. According to Soghoian (who'd been staying with friends):

> I came back today, to find the glass on the front door smashed. ...Inside, is a rather ransacked home, a search warrant taped to my kitchen table, a total absence of computers. I have no idea what time they actually performed the search, but the warrant was approved at 2AM. I'm sincerely glad I wasn't in bed when they raided the house.

The strong-armed tactics **created a backlash** of response against the Feds. A few days later, Markey retracted his call for Soghoian's arrest.

> **Six months later, very little had changed. Soghoian had retained attorneys and was—apparently—still negotiating with the FBI and other Feds about a resolution to his Web site.**

One privacy advocate noted that the FBI's tactics in dealing with Soghoian had had **a chilling effect on debate over the privacy issues raised by the FAA/TSA No Fly List**: "It's like the Feds said 'You think the No Fly List is an invasion of privacy? We'll show you what an invasion of privacy *really* looks like.'"

There had, in fact, been little public debate about real airport security versus what some experts called the "kabuki" process embodied by the No Fly List.

One proposed solution to these problems may be even worse—in terms of privacy. The Department of Homeland Security has proposed a "trusted flier program" that will allow passengers who carry federal ID cards to skip normal airport security lines.

> **Some privacy advocates suggest that the DHS allowed the existing airport security systems to remain ineffective, in order to justify the more-ambitious ID system.**

While the DHS hasn't commented on the "trusted-flier" ID program, a FOIA request filed by the Electronic Privacy Information Center confirmed some of the details of its development.

So, in terms of protecting personal privacy, the travel debate ends up by returning to old issues. First, the government's proposed remedy to security problems *that it has enabled* is a **national ID card system** that includes biometric features, etc.

Second, it relies on **the false choice between security and privacy.** A single-station security system in airports could provide both.

16

FAMILIES, CHILDREN & PRIVACY

Privacy isn't all just about you and your money. It's also about **keeping your personal *life* away from public attention**. If you have a family, it is probably the most important part of your private life. And, if your family includes children, *their* privacy may be a matter of safety and security.

In this chapter, we'll consider the various family issues that involve different aspects of privacy. In some cases, these issues relate to **keeping kids away from the public eye**. In other cases, they relate to family members—including kids—keeping things from you. And, finally, they may relate to **keeping family *traits* private**.

KIDS AND NETWORKING SITES

MySpace.com. Facebook.com. Xanga. Sometimes it seems like the Internet has become **one big chat room for teenagers**. And people interested in teenagers.

So-called "social-networking sites" allow people to post personal information about themselves and

then "meet" others whose interests are similar. The most popular of these sites focus on people under 25. And some offer an impressive array of services—including blogging tools, chat rooms, e-mail and various types of instant messaging.

> But the central point remains "networking"—that is, contacting—new people. The sites do all that they can to make networking seem safe, easy and fun. It may be fun and it may be easy. But it's not safe...it's a major exposure of private information.

In order to network effectively, a person has to publish personal information that he or she would be unlikely to offer strangers on the street. The slick promotion of the networking sites convinces users that they're joining a "community" of kindred spirits. Sometimes, this is true; often, though, users offer **personal details to anyone with a computer**.

If kids in your family (or you) want to make new friends through a social networking site, consider the following tips:

- Find out **how a site works**. Some networking sites will allow only a defined community of users to access posted content; others allow anyone and everyone to view postings.

- **Limit the information you post.** Restrict access to select groups with controlled membership—school, clubs, teams, community groups or family.

- Don't post your full name, Social Security number, address, phone number, or bank and credit card account numbers—and don't post other people's information, either.

- Be careful about posting **details that could be used to locate you** off-line—the name of your school, sports teams, schedules and where you work, etc.

- Make sure your **screen name** doesn't say too much about you. Don't use your name, age or neighborhood in any screen name. Even if you think the screen name makes you anonymous, it doesn't take a genius to combine clues to figure out who you are.

- Post only information or pictures that you are comfortable with others seeing—and knowing—about you. **Many people can see your page,** including your parents, your teachers, the police, the college you might want to apply to next year or the boss at a job you might want in five years.

- Remember that once you post information online, **you can't take it back.** Even if you delete the information from a site, older versions exist on archives and other people's computers.

- **Don't post photos of yourself**—or at least avoid "headshots" of other photos of only you. Among other risks, a photo can be altered in ways you may not be happy about. When you post a picture,

ask yourself whether it's one your mom would display in the living room.

- Avoid **long instant-messaging or chat exchanges** with anyone you've just "met" online. Because so many people lie about who they are online, you never really know who you're dealing with.

- Be wary of any online "friend" who wants to meet you in person right away. If you do decide to meet, be smart about it. Never go to the meeting alone. Meet in a public place, during the day—and make sure you take friends you trust.

The tip about schedules is especially important. Sexual predators and stalkers often look for public situations in which they can see victims in person. For adults, this usually means in the workplace; for kids, school or sporting events, etc. Some kids happily post their sports team schedules or other extracurricular activities for friends to see. These kinds of details should be kept private.

In January 2007, MySpace.com announced that it was developing parental-notification software. Under fire from both the government and parent organizations, the social networking giant said that its software would give parents a window into what their children put on their online profiles.

Parents or other family members could install the software on a home computer to see what any MySpace user who logs on from that computer listed

as his or her profile **name, age and location**. But it wouldn't give parents access to the *content* of MySpace profiles; and members whose profiles were being monitored would be notified that the software is keeping tabs on them.

> The software, code-named "Zephyr" had been in development since 2005. Several third-party applications that give parents access to their kids' MySpace activities had emerged in 2005 and 2006—but Zephyr was the first monitoring software launched by MySpace itself.

KIDS AND MEDICAL PRIVACY

After the issue of keeping private information out of public Web sites, the next-most-common family privacy issue is one that can drive parents and children apart. It's the issue of **a child's medical privacy**—what must be shared with...or can be *kept from*...a child's parents.

In November 2006, voters in California and Oregon considered ballot initiatives that would require parental notification for teens aged 15 to 17 years seeking to obtain abortions. Both measures included so-called "judicial bypass" provisions that would allow hearings before administrative law judges for teens wishing to avoid mandatory notification. Voters rejected both initiatives.

The controversy over parental notification laws has more to do with various groups' opinions on abor-

tion than on their opinions about privacy. Many public health professionals oppose parental notification laws. These professionals argue that minors are more likely to seek health care if they're assured that information will be kept confidential.

Adding to the confusion: Some public health groups *oppose* parental notification in cases of abortion but *support* it in cases of alcohol or drug abuse (specifically, at colleges and universities).

Amidst this confusion, the rhetoric used in the parental-notification debate highlights an important distinction for any discussion of privacy. How does privacy compare to confidentiality?

Conceptually, privacy is simpler than confidentiality. *Privacy* describes the ability to keep personal information away from others; it involves just two parties—the private one and everyone else. *Confidentiality* involves other parties. It describes the trust one party has that another party—who has been entrusted with sensitive information—will not share that information withy every one else.

In medical circles, privacy has been defined as the ability of the individual to maintain personal medical information in a protected way. Confidentiality, then, is the obligation of a health care provider not to disclose information.

HIPAA & PARENT NOTIFICATION

We spent an entire chapter of this book on the privacy issues raised by the Health Insurance Portability and Accountability Act (HIPAA). Those issues are complex; but they're kids' stuff compared to **HIPAA and parental notification.**

HIPAA includes so-called **"privacy regulations" specific to adolescents.** The law allows parents access to the private health information of their **unemancipated minor children**—except in limited circumstances, as defined by state law and local physician practice. State laws that afford more privacy protection override HIPAA; but state laws requiring parental notification are also allowed.

Believe it or not, the legal notion of a minor's "privacy" used by HIPAA comes from earlier federal laws related to children's school work. A child's confidentiality is protected under the **Family Educational Rights and Privacy Act** (FERPA), enacted in 1974 and amended in 1994 under the **Improving America's School Act** (IASA).

FERPA defines the term "education records" broadly to include all records, documents, files and other materials related directly to a student. **These records include the student's health records.** FERPA gives parents permission to have some control over the disclosure of this information—a kind of **general right to parental notification.**

IASA enhanced the penalty for improperly disclosing information from education records. Interagency

disclosure is exempted from these restrictions if it is within the **legitimate educational interest** of the minor. IASA also created four specific exceptions to FERPA disclosure rules; it allows schools to disclose student information without parental notification if the disclosure involves:

1) law enforcement records;

2) directory information (publication of name, address, phone number) after notification of intent;

3) a health or safety emergency; and

4) action taken under orders of the juvenile justice system.

Because of the various legal requirements of laws like FERPA, IASA and HIPAA, confidentiality for minors seeking sex-related health services has followed a convoluted legal course. Since 1942, the U.S. Supreme Court has considered citizens' privacy and liberty rights related to sexual activity from various perspectives. Since the early 1970s, the Court has struggled **balancing the child's right to privacy with the value of parental guidance**.

In 1970, Congress passed Title X of the Public Health Service Act. This law established a program to create a nationwide system of health care clinics that provided **"family planning services" (including birth control) to anyone who wanted them**. When the Title X program was started, services to adolescents were included; however, the growing rate of teen pregnancy alarmed Congress, which became concerned that teens still did not have enough access to information and services.

Congress amended Title X in 1981, requiring funded recipients to "encourage" minors to involve their parents in making reproductive health care decisions. The Reagan administration interpreted the word "encourage" to require Title X recipients to notify parents within 10 working days of prescribing a contraceptive drug or device to a minor.

In 1983, the Department of Health and Human Services issued regulations **mandating parental notification** for unemancipated minors seeking contraception from federally-funded family-planning clinics. These regulations became known, collectively, as the *Squeal Rule.* They were eventually overturned as unconstitutional by federal courts; mandatory **parental notification was ruled an illegal infringement of a minor's right to privacy.**

As it stands in the late 2000s, most states permit minors to seek the following: pelvic examinations, screening for and treatment of sexually transmitted diseases, counseling for and prescribing of contraception, prenatal care, treatment following sexual assault, substance abuse and mental health disorders—without notifying their parents.

Less uniform among the states are rules related to abortion, which may require either parental notification or judicial approval. In some states, adolescents can obtain an abortion without parental consent as long as notification has occurred.

OTHER NOTIFICATION ISSUES

As we've seen, parental notification rules generally fall into two categories: notification involving **health services related to sexual activity** and **everything else**. Some of the advocates who argue passionately *against* parental notification if a minor seeks an abortion argue passionately *for* notification if a minor engages in so-called "antisocial" behavior.

In 1998, Congress passed a series of revisions to FERPA that permitted schools to notify parents of students who are under the age of 21—if such students have **violated institutional policies regarding use of alcohol and other drugs**.

Specifically, the rules state that colleges do not have to hold disciplinary hearings before contacting parents. And they are not required to alert students that their parents have been notified. (However, a record of such activity needs to be kept in a student's file and released to him/her at his/her request.)

The FERPA revisions came at a time when academic institutions were confronted by parents wanting more information about their children. In a 1999 interview with the *New York Times*, Pennsylvania State University president Graham Spanier said:

We do not want to make [students] more childlike. But parents are constantly contacting us asking what is going on with their kids. They want *in loco parentis*.

Would he have offered the same justification for informing parents about a student's abortion?

In early 2000, a survey conducted by the Association for Student Judicial Affairs (ASJA) Model Policy Committee and Bowling Green State University produced some interesting results about policies that make college students "more childlike."

The survey was distributed to ASJA members representing approximately 600 schools. The results? Most schools were adopting more aggressive plans of **parental notification...of antisocial behavior**. Approximately 59 percent of respondents had policies in place to notify parents about such behavior **(primarily, heavy alcohol consumption)** and another 25 percent were actively considering the adoption of such policies.

COPPA

The Children's On-line Privacy Protection Act (COPPA) requires the Federal Trade Commission to **issue and enforce rules** concerning children's on-line privacy. These rules apply to operators of:

- commercial Web sites or online services directed to children under 13 that collect personal information from children;

- general audience sites that knowingly collect personal information from children under 13; and

- general audience sites that have a separate children's area and that collect personal information from children.

The FTC rules require these operators to:

- post a **privacy policy** on the homepage of the Web site and link to the privacy policy everywhere personal information is collected;

- give parents the choice to consent to the collection of a child's personal information—and *not* to have that information disclosed to third parties;

- provide parents with **access to their own child's information** and the opportunity to delete the information and opt out of future collection or use; and

- maintain the **confidentiality, security and integrity of the personal information** collected from children.

> **The privacy policy must be placed where it can be found easily, and it must be written so that the average person can understand what it says.**

To be COPPA-compliant, a privacy policy must contain the following information:

- **Contact information**, including the name, mailing address, telephone number and e-mail address of all operators.

- What types of personal information are collected—and how. Web site operators should be **specific enough** about the personal information they collect from

children **to allow parents to make an informed decision** about whether to agree to that collection and use.

- A statement of whether personal information is collected **actively or passively.** *Active collection* includes registration forms and e-mail newsletter sign-up boxes. *Passive collection* includes the use of cookies or other identifiers that use the personal information.

- How the Web site will use the personal information. For example, it should explain that e-mail addresses are used to send weekly newsletters, or that a mailing address is used to send a prize or fulfill another request.

- Whether the site offers activities that allow it to **disclose the child's personal information publicly**—through chat rooms, message boards, etc.

- Whether the **site operator discloses personal information it has collected from children to third parties**.

> The site also must give parents the option of consenting to its collection and internal use of their children's personal information while refusing to permit the site to share the information with third parties.

If the Web site shares personal information with third parties, the privacy policy must explain the

types of businesses the third parties are in and the general purposes for which they will use the information. The policy also must explain whether the third parties have agreed to **maintain the confidentiality, security and integrity of the personal information** they obtain from the site operator.

The Rule prohibits Web site operators from conditioning a child's participation in an activity—like a game or prize offer—on the child's **disclosure of more personal information** than is reasonably necessary to participate in the activity.

This provision prevents tying personal information from children to persuasive incentives.

> **For example, to send a child a prize, it is reasonably necessary for a Web site to collect the child's mailing address. Asking the child for a postal or mailing address when offering an e-mail newsletter would not be reasonably necessary.**

GENETIC PRIVACY

A final family privacy issue involves keeping **family traits** out of the public eye.

In February 2007, IBM—one of the world's largest employers—announced it was endorsing federal legislation that made it **unlawful to discriminate on the basis of a person's genetic code**. Harriet Pearson, IBM's chief privacy officer, said:

all this technology...social networking, advanced solutions that allow the health care industry to share across the ecosystem...raise questions of privacy.

Indeed, **advances in gene testing** enable doctors to tailor prescription medication to the individual and treat patients proactively against a predisposition to things like diabetes, cancer or heart disease.

But fear of discrimination could prevent some people from taking advantage of the technology. Privacy advocates worry that insurance companies might try to **deny coverage to those with a predisposition to a costly illness**—or that employers could decide against hiring or promoting someone on the basis of his known genetic limitations.

The bill—the Genetic Information Nondiscrimination Act of 2007—would **prohibit employers or insurance companies from making economic decisions based on genetic information**. It would also give genetic information the same confidentiality protection as a medical record.

The bill, which had been passed twice unanimously in the Senate, was reintroduced in the House in January 2007. It had bipartisan support. But variations had been brought up before...and been killed by strong opposition from lobbyists.

The U.S. Chamber of Commerce had consistently opposed genetic antidiscrimination bills, arguing

that the **Americans with Disabilities Act** already offered relevant protections. The group's position was that new legislation would lead to frivolous lawsuits and other problems.

There's some evidence to support these concerns. Unlike paper records, which can be hard to come by and harder to verify, a genetic test can quickly and definitively measure many things—from family ties to predisposition to health conditions like depression or alcoholism.

Not everyone is willing to give up their DNA to their employers (or insurance companies, etc.). Some worry about revealing family secrets; others fear that one DNA sample can be used to pry into other areas of their lives.

These risks are likely to continue. The same tests that determine whether two people share a common ancestor can also indicate much more about the people's health and family traits. *That's* personally identifying information that most people wouldn't want made public.

The main lesson to take away from all of this? In a world full of risks from various directions, the most practical way to think of privacy is as **the ability to control your personal information**. And doing that requires more than just one type of ID card or computer program. It means living your life carefully—and intentionally—to stay in control.

INDEX